Caulfield

Ruggles Street Publications
42 Central Street
Woodstock, Vermont 05091

ISBN 0-9701846-0-3

Book design by:
SYP Design & Production
www.sypdesign.com

Caulfield

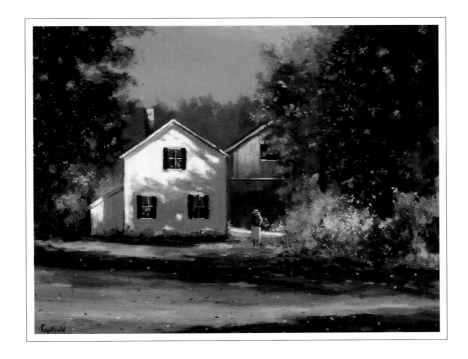

The Art of Robert O. Caulfield

WRITTEN BY
ROBERT O. CAULFIELD

for Marilyn

You made all things possible.
Then, now and forever my love will be with you.

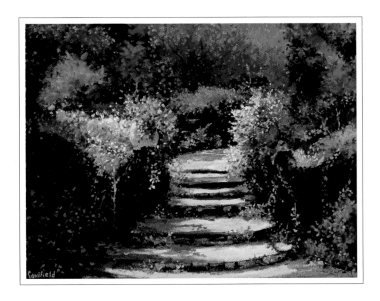

Acknowledgments

To my son, Wayne, whose interest in my art career lead to my owning my first gallery.

To my son Robert and his wife Pat, Cynthia, Lorelle and her husband Paul Govoni, Wayne's wife Ann, and to my grandchildren, Kelly, Todd, Krystle, Kimberly, Brian, Kaitlin, Brendan, Travis, Camille, and Julia, for their inspiration and encouragement.

To John Amann, owner of the Phillips Galleries in Palm Beach, Florida and Harbor Springs, Michigan, for his many years of guidance and for asking me to do some beach scenes years ago.

To Lester Fein, one of my collectors, for encouraging me years ago to do more scenes of New York City, which, as it turned out, have been some of the finest work I've done.

To my many collectors, for their support through the years. Without them this book and my career would not have been possible.

And finally to my son, Craig, for his invaluable assistance in helping me compile this book.

Foreword

Robert Caulfield's paintings pay homage to the gentle side of life.

His use of light and color convey a deep feeling for cherished places and moments, and his powers of observation make the dialogue between artist and viewer more expressive and poignant.

—Tom Kellaway, Editor
American Art Review

One of the leading street painters in the nation.

—Patrick Sarver, Editor in Chief
Art Trends Magazine
March/April issue, 1998

One of the leading impressionists in the nation.

—Patrick Sarver, Editor in Chief
Art Trends Magazine
October issue, 1998

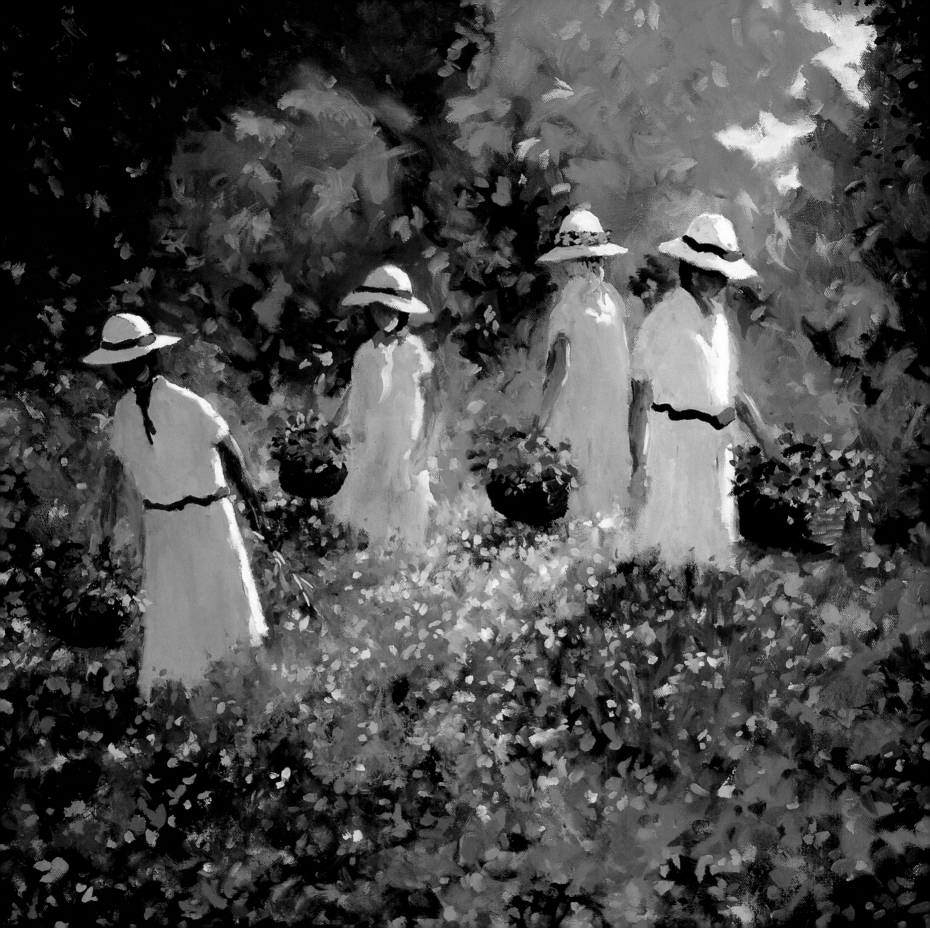

Introduction

My father was the first-born son of Owen Caulfield, an Irish immigrant and his wife Mary, the American-born daughter of parents who had left the Azores in the east Atlantic a generation before. When my mother met my father in the summer of 1928, she was a young woman of eighteen from a family with deep roots in New England and Nova Scotia. They married in 1929 and my older brother, Joseph

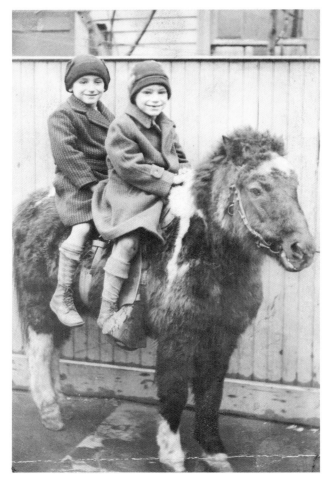

Roxbury, Massachusetts, 1936. Me up front and my brother, Joe behind me.

was born soon after. My birth in December, 1930 coincided with the nation suffering through the most dismal days of the Great Depression. Soon after my arrival Joe and I were entrusted to the care of my maternal Grandmother Stoner.

My parent's marriage proved difficult from the start. Frail and sickly, my mother was overwhelmed by the demands of parenthood and the severe financial struggles common to many at that time.

The source of my ambition and drive to paint remains a mystery to me. My parents showed neither an inclination to create art nor an appreciation for it.

My earliest memory is of being six years old and spending endless hours drawing in chalk on the sidewalk, under the thousands of blinking lights of the Roxy Theater marquee. We lived just across the street, in Roxbury, Massachusetts. It was a poor, dangerous, crime-ridden neighborhood near Boston; what would now be referred to as inner-city.

Though I have no doubt that our Grandma Stoner had a fierce love for us, she was no disciplinarian and more or less let Joe and I run wild on those perilous city streets. You can imagine the endless scrapes and adventures we got ourselves into. I saw my mother rarely, and my father on the not-that-rare occasion when he had to visit school to prevent the authorities from expelling us.

My father's mother, whom we called Gramma, became an ever more frequent visitor from the North Shore seaside city of Lynn. Many years later we learned she was horrified by what she viewed as Grandma Stoner's neglectful parenting. She and Grampa Caulfield were determined to raise us in a more structured environment. In retrospect I'm amazed that two seniors, well into their

mid-sixties, would have taken on the task of raising two wild, scrappy boys from the streets. But two more decent people have never lived. My Aunt Dot and Aunt Mary also lent a hand in our upbringing.

Joe and I moved to Lynn in about 1940, when I was ten. Long after separating, my parents finally went through an acrimonious divorce in 1941, after which visits from my mother became increasingly rare.

Gramma Caulfield was the first person to appreciate my artistic talents. She was quite proud of all the drawings I did and often displayed them for friends and family. A seminal event in my young life was when she and Grampa presented me with a set of oil paints on my eleventh birthday. I haven't looked back since. Under Gramma's and Gramp's care Joe and I thrived. I attended parochial school and in the seventh grade my teacher, Sister Constantius, constantly encouraged my drawing ability. She soon had me copying the illustrations from our daybook on the chalkboard. The occasional paper airplane or insult would zip by as I worked. But when I finished, my schoolmates would crowd around, patting my back and saying that they wished they could draw like I could.

One thing I've always believed is that, though many people are talented, talent without persistence and hard work equals nothing. The craft of the artist is mastered as is any other—with discipline and constant practice. Visitors to my gallery and

Marine Corps., 1951

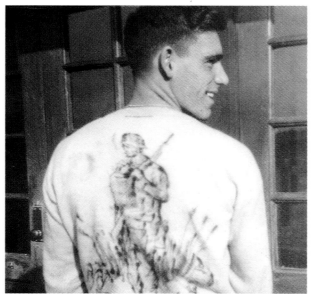

In the Marines, 1951.

studio often say, "I wish I could do that," or, "It must be so wonderful to paint every day." It is. But many seem to think there's some kind of magic or alchemy involved in creating a picture. There isn't. Painting is work; often difficult, sometimes not, and best when touched by inspiration. I'm also quite often asked why I'm primarily a landscape artist. My childhood spent on the congested city streets of Roxbury may have something to do with it. I left the neighborhood rarely, and when I did, I was overwhelmed by all the new sensations something as simple as a trip to the beach might offer. Landscapes are simply what appeal to me most as a painter.

In my early teens, as World War II raged, I admired most those artists whose illustrations rendered scenes of war for *Life* and *Look* magazines. The works of Ogden Pleissner, Fletcher Martin and Reginald Marsh had a profound

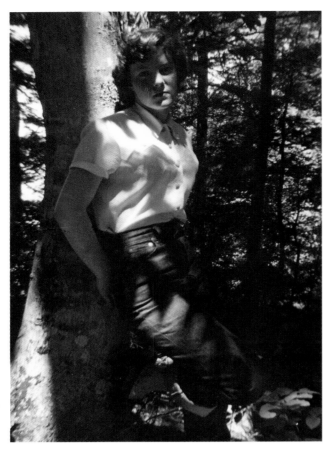

Marilyn at seventeen in 1952.

every head, limb and torso to perfection.

My father was a shadow figure, on the perimeter of our lives at best. He seemed reluctant to have anything to do with me or Joe. My mother became an ever more elusive figure, and the time between her rare visits grew longer and longer. One day I took the train into Roxbury to see Grandma Stoner and show her a prize I'd won for my artwork, but she had moved away. I've never seen her or my mother since.

Toward the end of 9th grade I discovered football. A caretaker at a local field saw me throw a 50 yard pass, and he told the coach. Soon I was captain of the junior varsity team. We went undefeated my sophomore year. During the off-season I went out for track and won a bunch of medals. However, I suffered a severe knee injury the following spring that almost derailed my budding athletic career.

My High School art teacher advised me to study art seriously after graduation, but there simply wasn't enough money to think of college. Art scholarships were hard to come by in those days, and a broken ankle in my senior year further hurt my chances of obtaining an athletic one. An indifferent student at best, I preferred sports, drawing and girls, though not necessarily in that order. Joe and I lived comfortably with Gramma and Grampa, but college seemed like something only the rich could afford. Grampa's work ethic was impressive. He worked as head chef at Boston's famous "Durgin Park" restaurant until he was almost eighty.

Shortly after High School graduation I spotted a girl on the beach. I'd noticed her a few times as she'd breezed by me in our school corridors. Marilyn

About the time I was doing my series of Beacon Hill scenes, 1969.

effect on me. Whenever their work appeared, I'd study every aspect of their illustrations and try to reproduce their techniques. I even wrote a letter to Life in 1944, telling them that one day I was going to be one of the best artists in the nation. By ninth grade I was a head taller than everybody else in school. Our coach talked me into trying out for the basketball team, and I discovered I had a gift for athletics. Soon our team won the Essex County Championship, and I became one of the team captains.

I drew every day. I copied anything and everything from newspaper photos to illustrations in magazines and books. I studied an anatomy book for artists until I could reproduce

LeBlanc was her name and she was a sixteen-year-old sophomore. I asked my best friend, her cousin, to go over and ask her if she'd go out with me. Marilyn replied, "If he wants to go out with me, let him come over and ask himself." I summoned the courage and it was the single best move I ever made.

Marilyn and I began dating, and to earn extra money I joined the Marine Reserves with a couple of my old football teammates. Much to my surprise, our one night a week training sessions soon escalated to two. Before I knew it I was off to Paris Island for thirteen weeks of basic training, in preparation for serving in the Korean conflict. I spent the next two years stationed in Southern California and never went overseas. I made time for sketching whenever possible. When I painted a scene in oils on my sweatshirt, everybody in my company wanted me to paint one on theirs too.

Returning home to Lynn in the fall of 1951, I was soon engaged to Marilyn. We married in August of 1952. Any dreams of attending art school now faced the very real need to support my family. A son, Robert Leon, was born in 1953 and a daughter, Cynthia, followed in 1954. I was determined that my children would have the childhood I'd been deprived of and that I'd never go through a divorce. Once in a while, on humid summer weekends, I would take my young family to the coastal art colony of Rockport, Massachusetts. I can still see myself holding hands with Marilyn and pushing a stroller, dreaming of one day owning my own art gallery.

My art studies were relegated to once-weekly drawing sessions at the Practical School of Art in Boston. Over the next two years I studied line drawing, and the basics of design and composition part-time-nights at another school in Boston, the New England School of Art. My formal art studies ended in 1954 due to the increasing demands of my growing family, but I remain a life-long student. My collection of art

Sketching on Boston Common, mid 1980s.

books would rival those of many libraries. Never having had a mentor's influence, nor having studied oil painting formally, I've developed a style that is uniquely my own.

Around this time I entered a national competition. Edward Hopper, the great American realist painter, personally judged. He chose my painting from over a thousand entries, as one of the "Best of Show". I can still visualize that painting, a rainy day scene of nuns exiting a church, as it hung between the work of Emil Gruppe and Stanley Woodward.

In the end, a painting as an object simply exists in light, shape and color. The French Impressionists and their search for uncompromising realism was radical in its day, smashing the old methods practiced for four centuries.

This paved the way for the departure from traditional forms. The Twentieth Century exploded with many invigorating and exciting artistic movements, from Dada and Cubism to Action Painting and Abstract Expressionism, on to Pop and now Post-Modernism.

But through all this the average person seems to have become more distanced from art. Many find Abstract Expressionism hard to follow, cold, understood only by the insular New York art world.

As more or less a realist with leanings toward Impressionism, I hope any viewer can look upon my work and feel an emotional response to the natural world I'm drawn to portraying. Though I'm unsure where I first heard it, I believe "All art aspires to the condition of music." Just as various forms of music can move your emotions in different ways so should a painting—with your heart. Art isn't elitist—it's for everybody. All the arts have points in common. Artists who feel the public can't understand their art might be saying more about their own alienation, than about the public's.

Maybe self-expression has been stressed over craft too much in avant-garde circles. But a fine painting will always capture people's interest despite the art trends of the moment.

In first-rate avant-garde art one often sees a continuation of the quality standards practiced by the Old Masters in the first place. The basic rules are the same; in the end every artist uses abstraction to some degree. Art is directly tied to the period that produced it. I'm often asked why the figures in my beach scenes are in Victorian dress, or why I don't paint the grittier side of New York City. The reason could be nostalgia for what evokes a seemingly more romantic time but in reality probably wasn't. This looking back might reveal more about our present than I'd expected. I try not to be overly philosophical about art, especially mine. I simply paint what appeals to me.

The waning years of the 1950s found me displaying my work in galleries on the North Shore of Boston and throughout New England. Our third child, Craig, was born in 1959. The '60s would bring two more children, Lorelle in 1961 and Wayne in 1965. My focus remained on providing for my family. I remained at my day job for financial security, rising through the years to an executive position.

As the social upheavals of the 1960s gathered steam, our family settled in the nearby suburb of Lynnfield, Massachusetts. I became involved with a couple local art associations and was elected president of one of them. However, the art world can be extremely political; I decided I wanted to spend my limited free time painting, not discussing art theories and handing out prizes. In the years since, I've kept my involvement in art associations to a minimum. I set up a studio in the basement and painted nights and weekends while working sixty hours a week or more.

I lost my beloved grandparents in the late '60s. Both had the great good fortune to live to almost ninety years of age. Marilyn, our five children and I had settled into a classic American suburban lifestyle and the years passed happily. Exhibiting at a steady clip, my work sold well and won an occasional award. In the late '60s and early '70s, a series of my Boston Beacon Hill scenes garnered a lot of attention. A few of those paintings are included in this book.

The dream I'd long had of owning my own gallery was postponed, and gladly so, as I helped three of my children graduate from college. In the mid-'70s I was asked to become a member of the Copley Society of Boston. Shortly after, I had my first exhibition in New York City.

Reaching age fifty in 1980 I re-evaluated what I wanted to achieve as an artist, and began considering early retirement. This desire accelerated late in 1983 while on a painting and photography

A recent photograph of Marilyn and myself.

given up our comfortable lifestyle to take on all the risks involved in the art world. But she never wavered. Nothing I've achieved in my life would have been possible without her tremendous love and support. Our fiftieth wedding anniversary is fast-approaching in 2002. We have been blessed with ten grandchildren, and a couple of them seem to be as obsessed with drawing as I was at their age. Meeting the thousands of people who have visited my gallery and studio has been a wonderful pleasure.

I still paint almost every day and hope to continue doing so for many years to come. These days I don't spend much time in preparation, mostly relying on sketches. In my younger days I did far more work "plein air," and on occasion I still head outdoors with my paint box and canvas.

trip to Vermont with my son, Wayne. "Dad, stop the car!" he yelled, as we drove past a Colonial brick house with enormous front windows, on Central Street in Woodstock. "Look at that 'For Sale' sign," he said. In a hurry to get back home, I didn't want to stop. But for some reason I did.

My lifelong dream of owning my own gallery was realized in that house in the summer of 1985. In retrospect I can see that my palette of colors began to change around this time, too, from the darker colors of my earlier years, to the vivid colors I now use in my beach scenes.

The days roll into years, and I've seen my work enter private and corporate collections all over the world. Aside from my gallery in Woodstock, I continue to exhibit in select galleries in Palm Beach, New York City. Carmel, and Michigan.

Marilyn has been at my side every step of the way. I'm not sure how many women would have

It's been almost sixty years since Gramma Caulfield gave me that first set of oil paints, and still I feel that thrill and challenge every time I sit down at my easel or pick up my sketch pad. My success has enabled Marilyn and I to travel far and wide. The following plates are representative of some of those travels. They encompass paintings done primarily during the last twenty years, though some go back as far as thirty-five years.

It is my hope that through my paintings, you might see something familiar, in a slightly different way.

Camille Pissaro, my favorite artist, explained his thoughts about his work in a letter to his son, Lucien: ..."It is only in the long run that I expect to please...but the eye of the passerby is too hasty and sees only the surface. Whoever is in a hurry will not stop for me." I couldn't express how I feel about my own work any better.

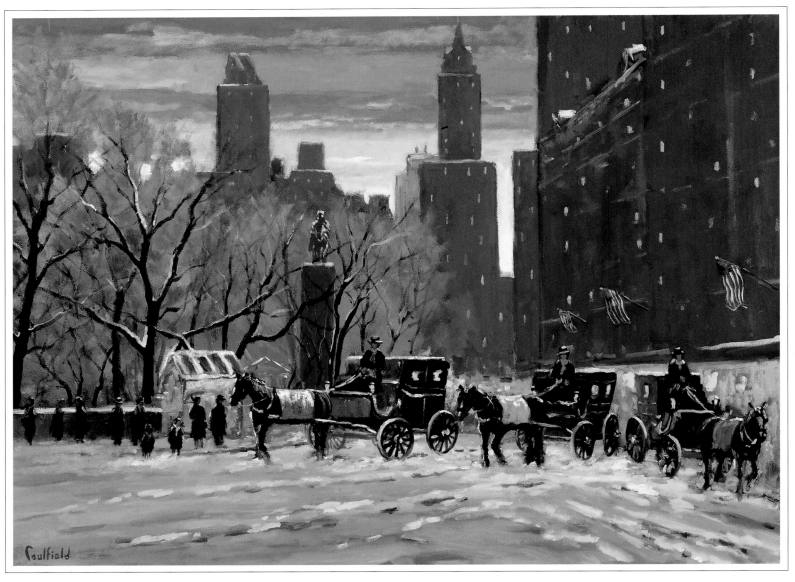

Dusk, Central Park 22" x 30" oil on canvas

Collection of Dorothy and Donald Hunt

Earlier Works

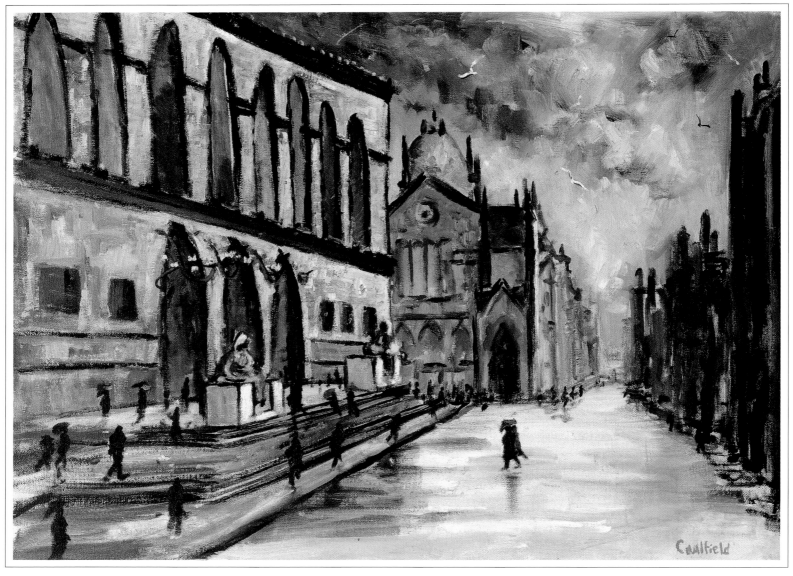

Boston Public Library 18" x 24" oil on canvas

Collection of Boston Gas Company

This scene is a good example of the darker palette
I favored in my younger years.

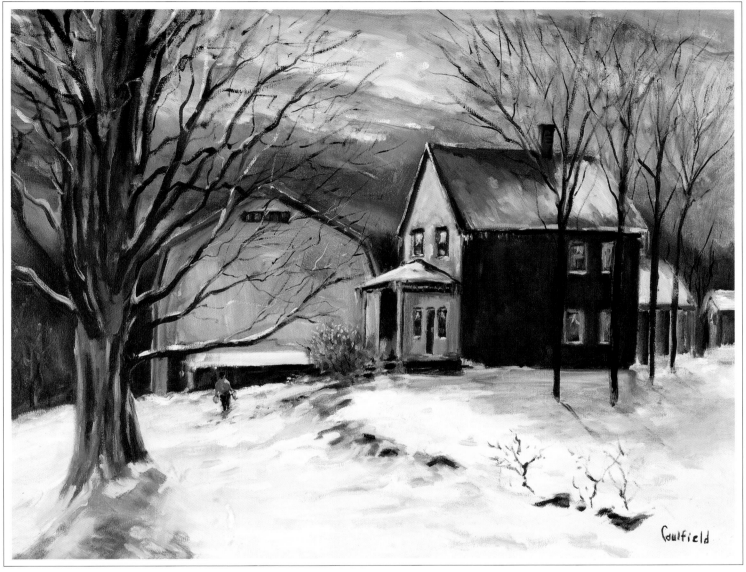

Winter Sky 20" x 24" oil on canvas

Private Collection

The Patton Area of western Massachusetts is primarily farmland. I was passing through years ago when this scene caught my eye. The dark winter sky sets the mood, along with the old house and barn. The maple tree on the left, its bare branches lightly covered with snow, adds balance. A partially obscured stone wall and a farmer carrying a bucket, complete the composition.

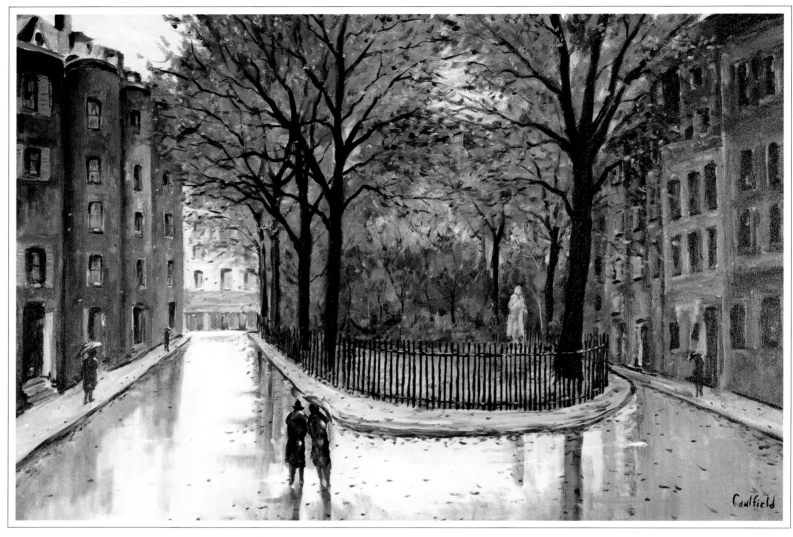

Louisburg Square, Boston 24" x 36" oil on canvas

Collection of Les and Cecile Fein

Louisburg Square is a small courtyard surrounded by cobblestone streets on Beacon Hill. When I ventured there to paint "plein air" in my late twenties and early thirties, the magnificent townhouses surrounding the square were neglected and had seen better days. Once in a while an upper window would bang open, and one of the elderly residents would call out and invite me up for lunch. I met a couple very charming old Brahmins that way, and still remember making conversation over finger sandwiches, while keeping one eye out the window on my easel.

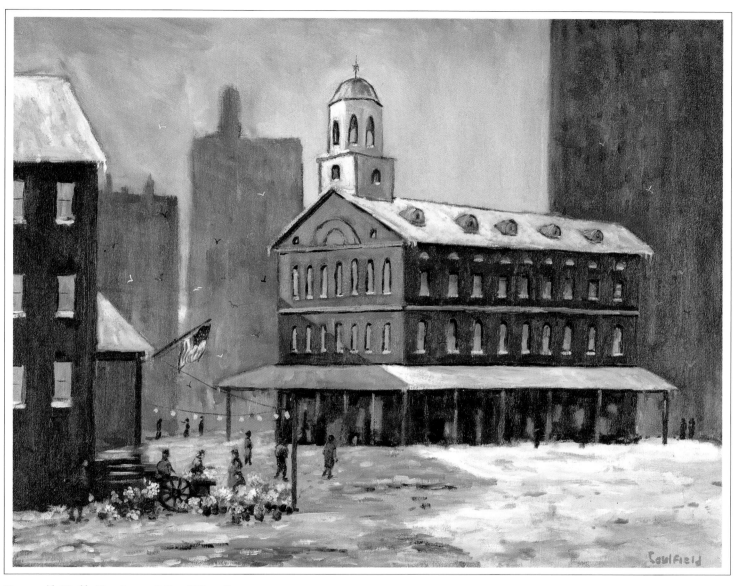

Faneuil Hall, Boston 24" x 30" oil on canvas

Collection of Dorothy and Donald Hunt

Faneuil Hall is one of many historic landmarks in and around Boston. I painted this scene thirty years ago, before the Hall was incorporated into Quincy Market. At that time there weren't as many high-rises; the buildings adjacent to Faneuil Hall were abandoned except for Durgin Park, the restaurant where my grandfather worked for many years.

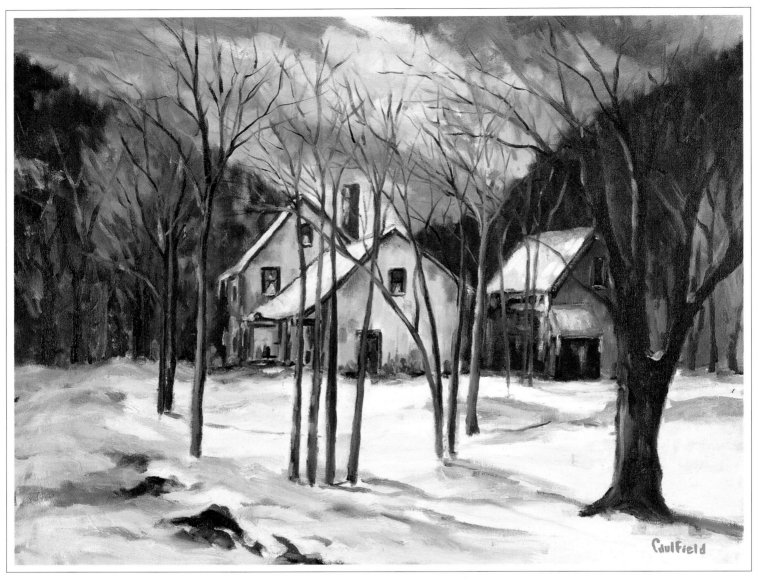

Moscow, Vermont 20" x 24" oil on canvas

Collection of Marilyn Caulfield

I took all of my children on painting expeditions when they were young. In the early '70s I headed to Vermont with my son, Craig, in tow. Moscow is a village outside of Stowe, and this particular scene caught my eye as we drove along a quiet country road. I still remember standing there in the freezing cold, in waist-high snow, with my son painting at his little easel beside me. I completed this painting in one day. Upon showing it to my wife, she immediately entrusted it to her "private collection", where it still remains. It's Marilyn's favorite painting.

Lorelle In Childhood

24" x 30" oil on canvas
Collection of Mr. and Mrs. Paul Govoni

I painted many portraits of my two daughters when they were younger, though as the years have passed I've focused primarily on landscapes. Color in this portrait was kept to an absolute minimum, to keep the focus on Lorelle's melancholy features. As a child Lorelle was quite somber; she could communicate this with merely a heartbreaking glance. I never completed the face, but feel the piece works quite well in this state.

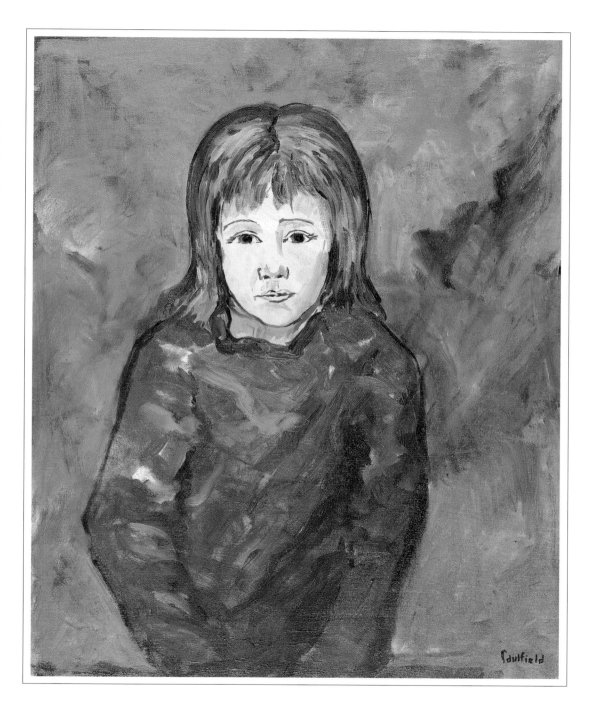

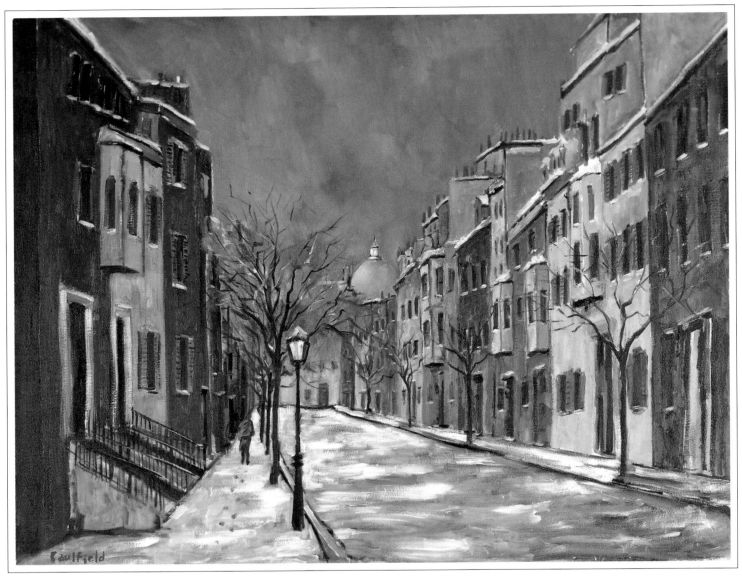

Beacon Hill, Boston 24" x 30" oil on canvas

A dark sky emphasizes the bulk of the old brick-faced buildings. The ice-coated street reflects the interesting patterns created by tightly packed apartments and townhouses A lone figure approaches the background along a lyrical line of barren trees, toward the golden dome of the State House. I can often see influences in my paintings from artists I've studied, and I see a bit of Utrillo in this work.

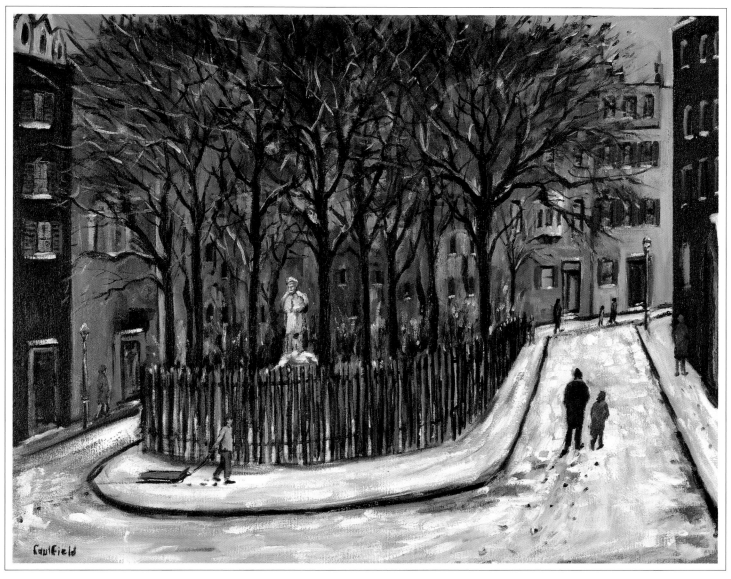

Louisburg Square, Winter 24" x 30" oil on canvas

Collection of Boston Gas Company

I painted the Square a number of times through the years. This winter scene, with its exaggerated perspective and untamed jumble of trees, has a certain force and energy I find appealing.

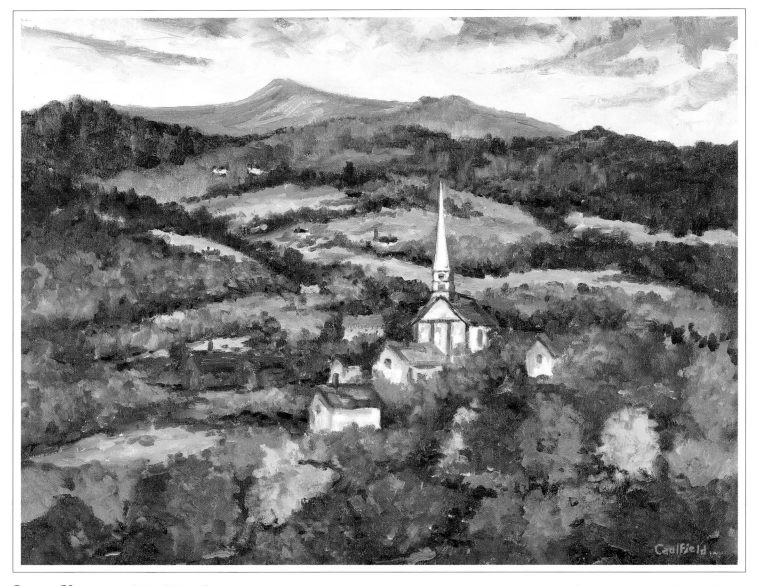

Stowe, Vermont 24" x 30" oil on canvas

Collection of Marshall and Mimi Mazzier-Heuser

I have gone to Vermont to paint since the 1950s. This fall scene was completed in the late 1970s, years before I moved to the state permanently. It was the first of my paintings to be published in a national magazine.

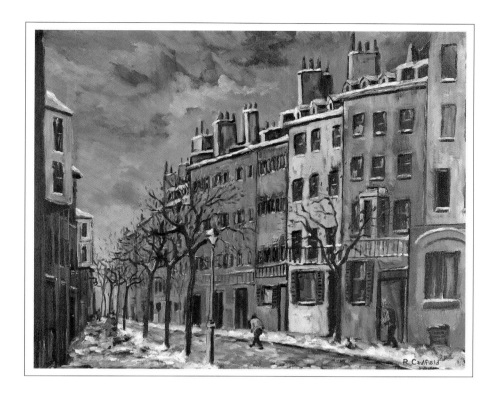

Beacon Hill, Late Winter
24" x 30" oil on canvas
Collection of the artist

Beacon Hill
20" x 24" oil on canvas
Collection of the artist

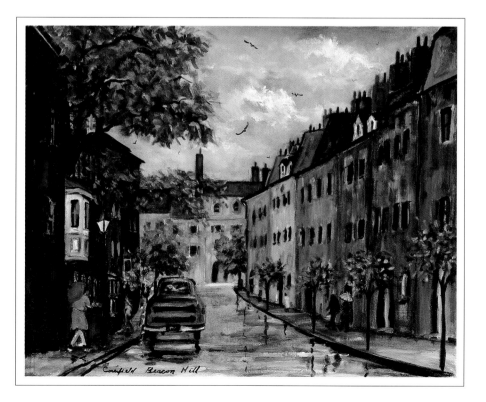

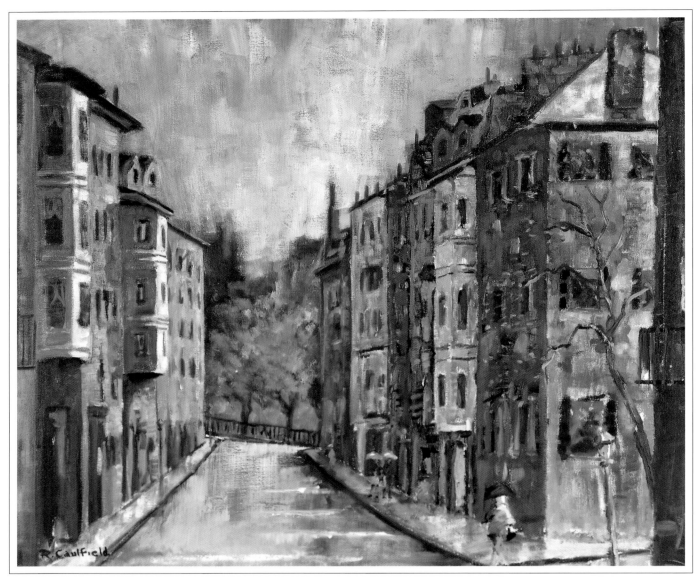

Chestnut Street, Beacon Hill 24" x 30" oil on canvas

Collection of the artist

In the 1960s and early 1970s Beacon Hill was one of my favorite subjects. I did over one hundred paintings in this Boston neighborhood of eighteenth and nineteenth century brick townhouses and winding streets. My work there proved to be a great training ground, as I set up my easel in all seasons and in every type of weather.

1985 – 2000

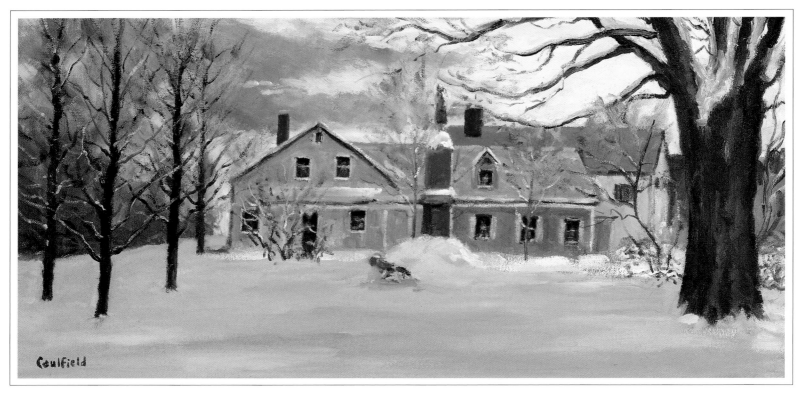

Caulfield Art Gallery 12" x 24" oil on canvas

Collection of the artist

Our home not only encompasses the gallery but my studio as well. Located on Central Street in Woodstock, it's adjacent to Tribou Park, a small green with a Civil War memorial and an old cannon. I chose this vantage point, looking west, to emphasize the purples and pinks of a winter sunset.

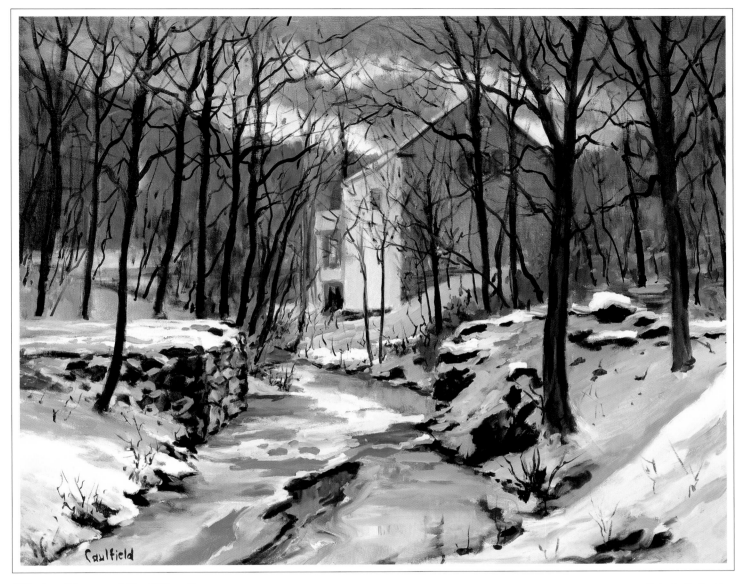

Winter Stream 24" x 30" oil on canvas

This stream lies across the street from the Kedron Valley Inn in Woodstock. I completed most of this painting on the spot, and the temperature never rose above twenty degrees that afternoon. The next day, as I put the finishing touches on it in my studio, a client walked in and bought it, still wet, off the easel.

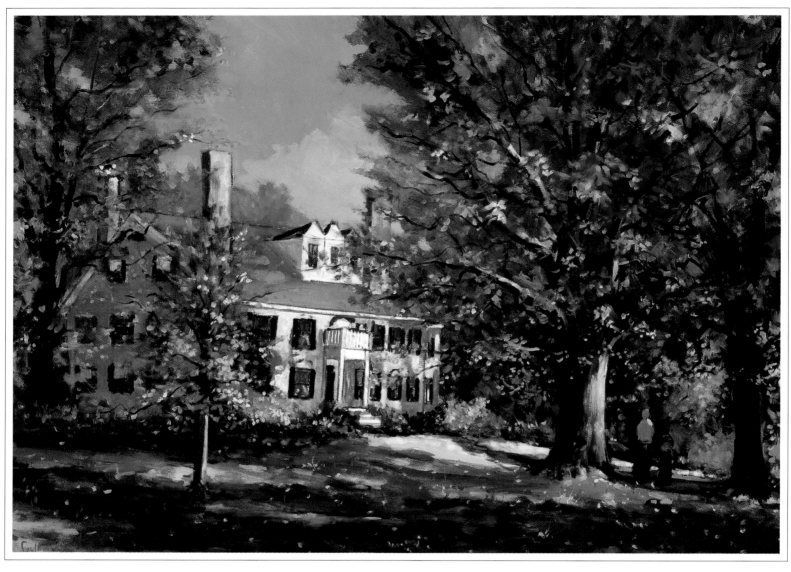

Fall Shadows, Woodstock 22" x 30" oil on canvas

Collection of Gladys Douglas-Hackworth

I established my visual field between the house and trees; the fine brick house becomes the focal point in this painting. Although in shadow, the trees are rich with fall colors. I added the figure in various shades of blue for balance.

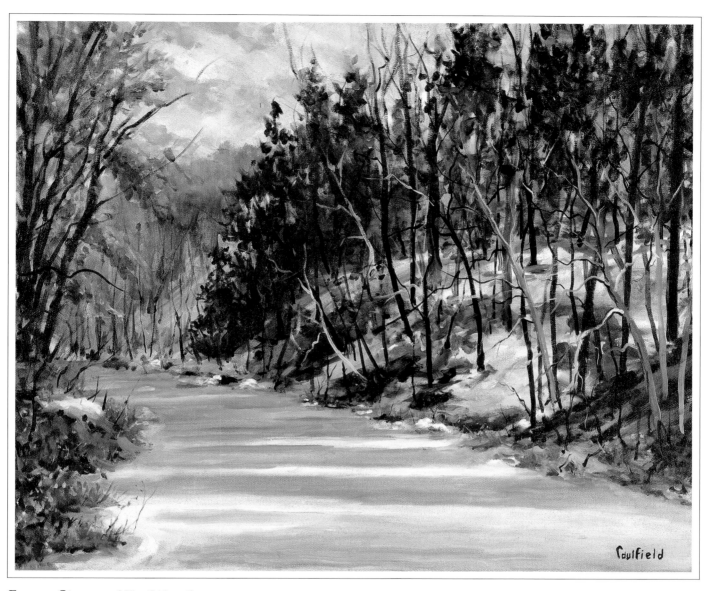

Frozen Stream 20" x 24" oil on canvas

Collection of the artist

The back roads of Vermont offer endless scenes to
paint, and I came upon this one near Woodstock.
I set my easel up right on the ice that winter day.
Wind and the scraping of my brush on the canvas
were the only sounds I could hear. By the time I
finished, my fingers were numb from the cold.

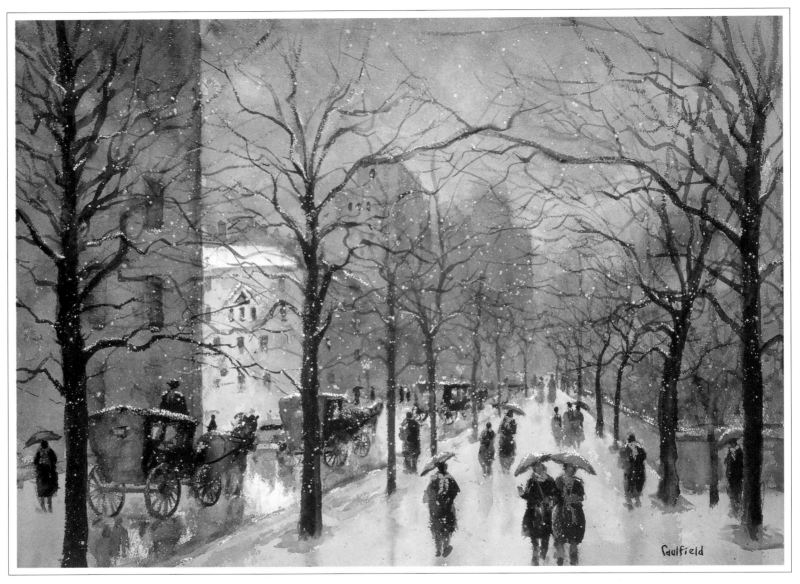

Light Snow, 5th Avenue 22" x 30" watercolor

Collection of Vahram and Lisa Erdekian

This painting, reproduced as a lithograph, has been very popular. People tell me it's evocative of one of those gray New York winter days. I was leaving the Metropolitan Museum one afternoon; I took a series of photos and then made some quick sketches. In my studio, a light sky was laid in with Paynes gray, Prussian blue, burnt umber and titanium white. Very light purple was used for the distant buildings. On a rainy day trees have a tendency to look black, as they do here. Feeling it was a distraction, I left a large sidewalk fountain out of the painting. My familiar theme of horse-drawn cabs completes the scene.

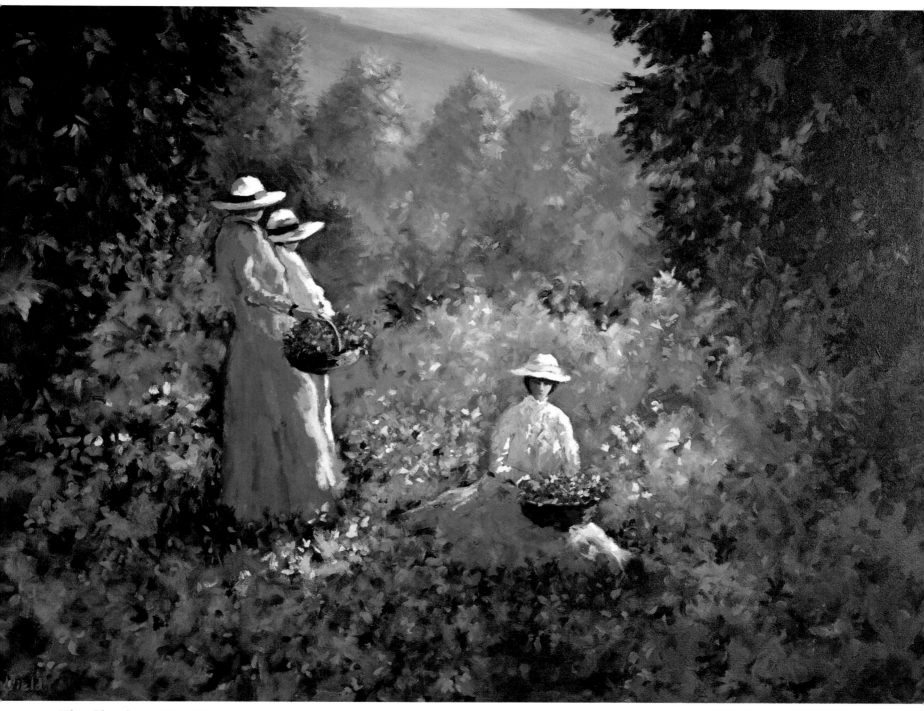

The Clearing 30" x 36" oil on canvas

Collection of Stephanie Fein

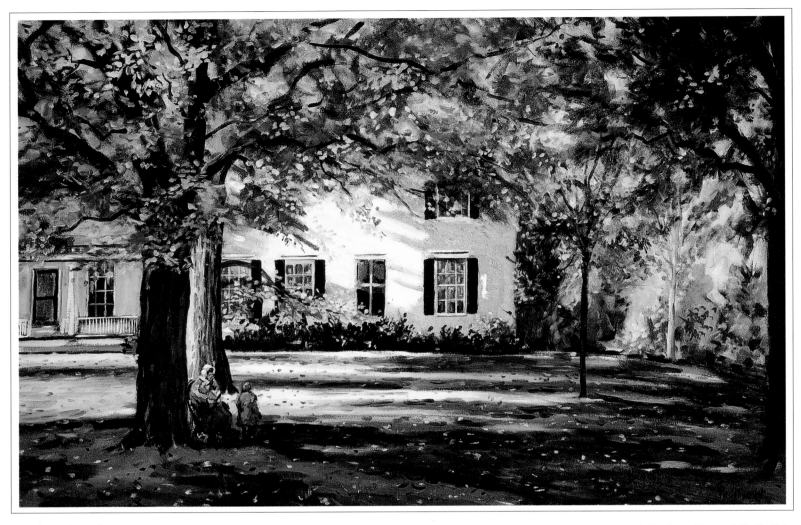

Under The Elms 23" x 25" oil on canvas

This house stands on Elm Street in Woodstock. Here on a crisp fall day, its windows reflect splashes of autumn color under a cerulean blue sky. The house is primarily rendered in sun-splashed Naples yellow with lighter highlights. Contrasting dark trees of Vandyke brown, burnt umber and Prussian blue, stand in a foreground of dark purple, with occasional dashes of color for fallen leaves. A woman reading to a child completes the composition.

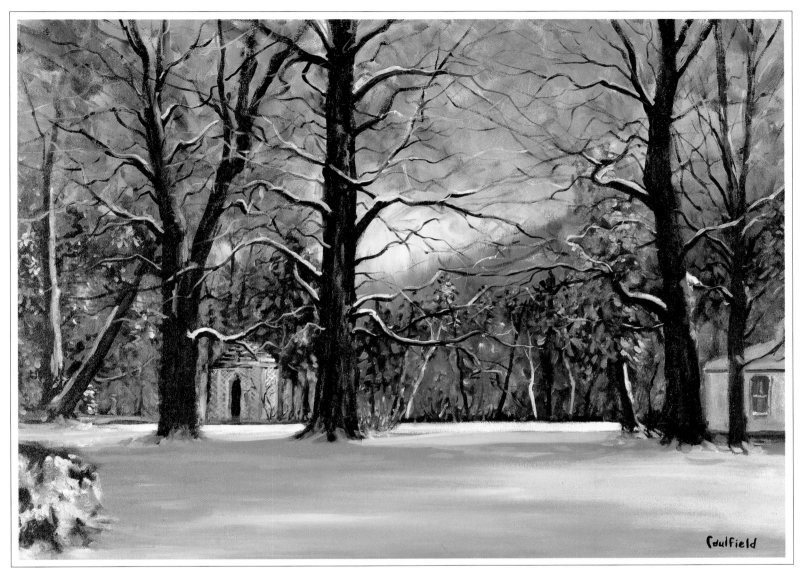

December Shadows 22" x 30" oil on canvas

This gazebo sits in a yard down the street from my house in Woodstock. I've painted it in summer and fall, but this winter scene, with its long early-morning shadows and soft northern light, is my favorite. By casting the foreground snow in shadow, I was able to create an interesting highlight behind the ominous trees.

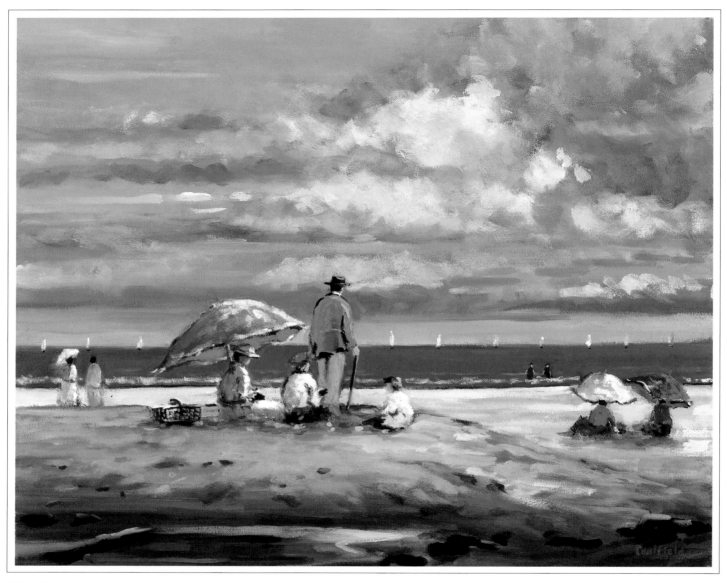

Tide Pool 20" x 24" oil on canvas

This is one of my earlier beach scenes. Emphasis here was placed on the cloud-filled sky set against the darker foreground. The figures are smaller than I would paint them today.

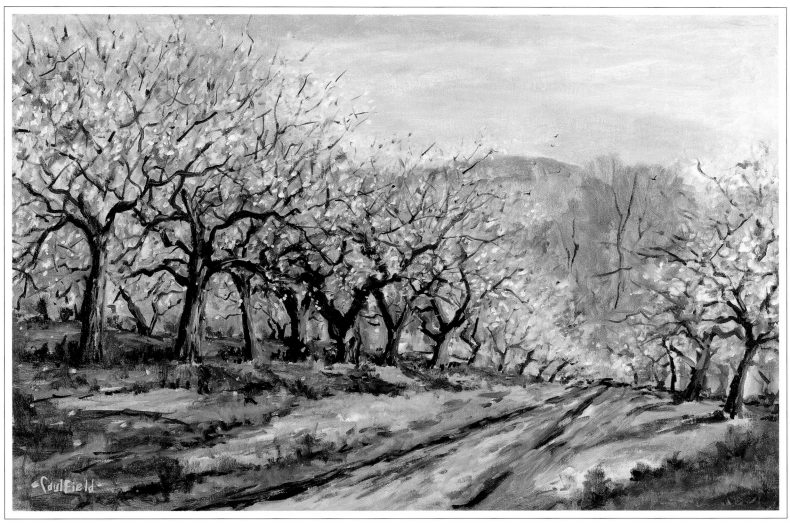

Moore's Apple Orchard 24" x 36" oil on canvas

Collection of the artist

Spring arrives late in the north, and when it does come after another seemingly endless winter, it's very much appreciated. This orchard isn't far from the gallery, and the elegant apple blossoms last only a few weeks. I remember standing at my easel and swatting honey bees, as I dabbed my brush in burnt umber to represent the twisted, gnarled trunks of the trees. The perspective recedes toward a calm cerulean blue sky, which sets the warm tone for the vivid white blossoms and field of green with patches of yellow ochre.

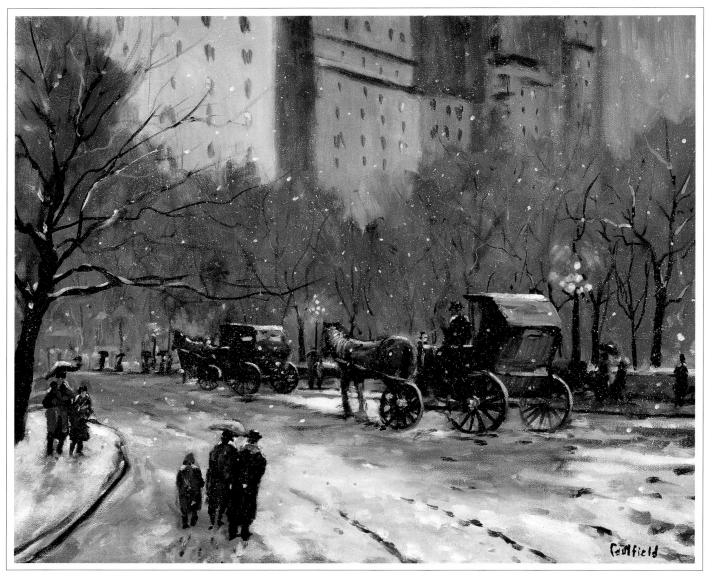

5th Avenue and 59th Street, NYC 20" x 24" oil on canvas

Collection of the artist

I have visited New York throughout my life, but didn't begin seriously painting scenes of the city until a collector suggested I do so in the mid-1980s. This is one of my earliest New York scenes. I've explored the subject of horse-drawn cabs many times during the ensuing years. Here I use a fluid style and flat lighting to suggest an oncoming evening snowstorm.

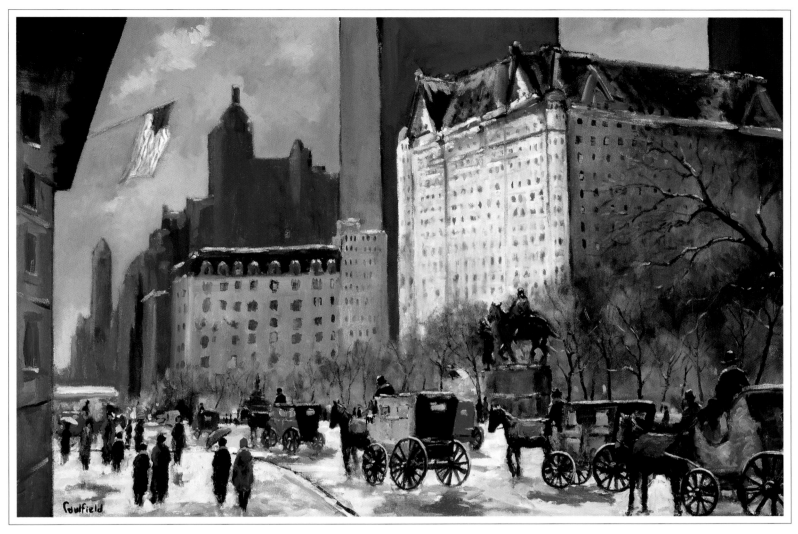

Winter Evening, The Plaza 24" x 36" oil on canvas

A romantic view of Manhattan.

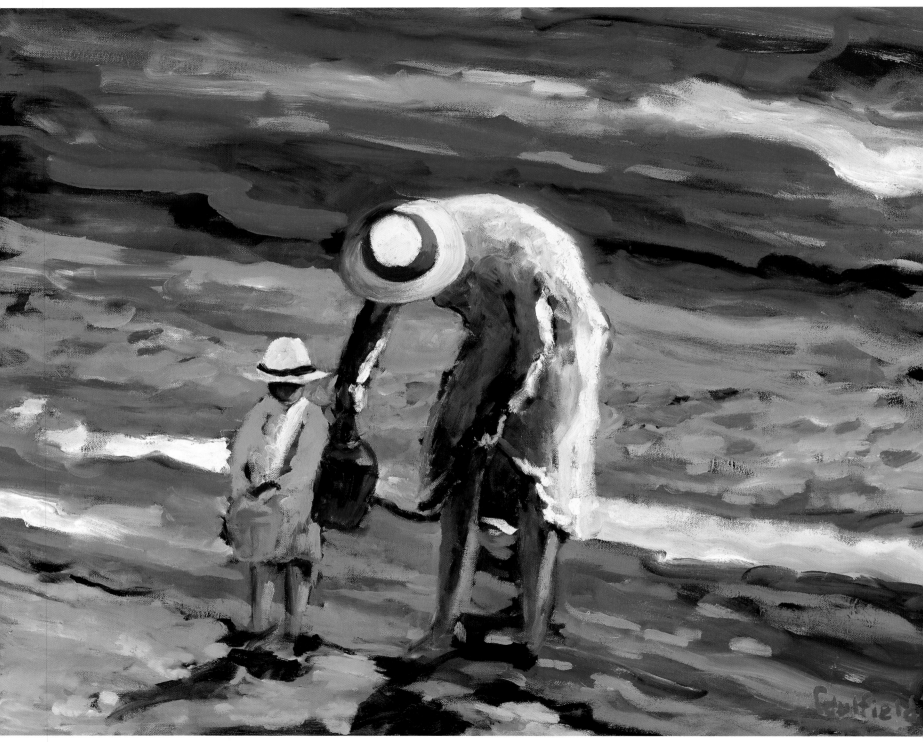

Sandpails 24" x 30" oil on canvas

Collection of Betty and John Trinder

40

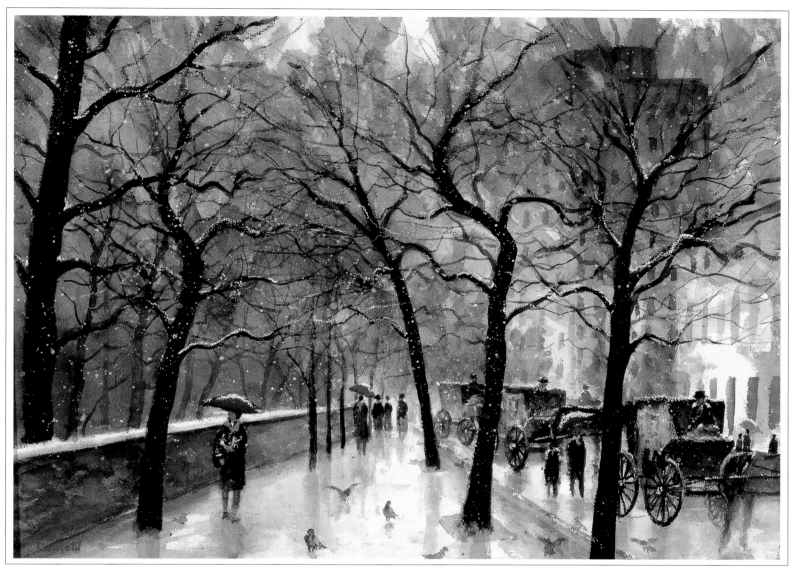

December Day, NYC 22" x 30" watercolor

Collection of Susan and Robert Goldstein

I consider oils my primary medium, but I enjoy the completely different set of effects one can attain with watercolors as well. In this scene, a raw, wet winter day in New York seems all the more so, with the steel-gray chill reflected by the rain-slicked sidewalk and the threatening skies above.

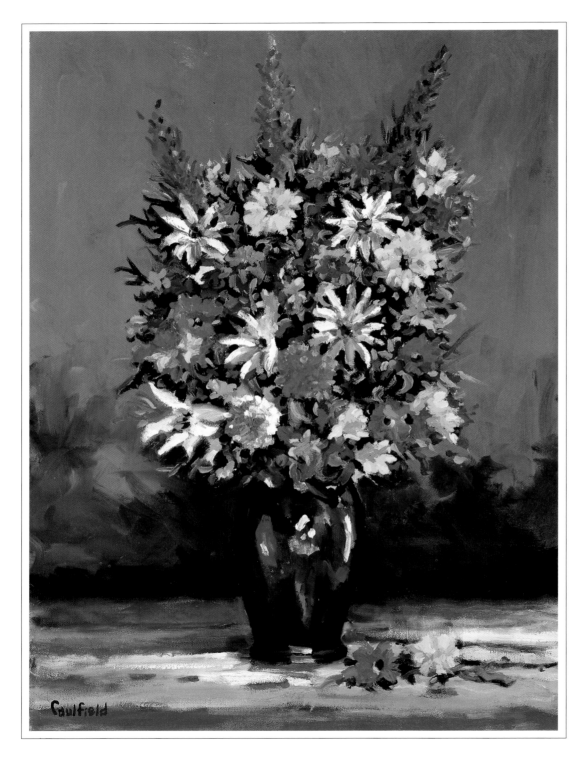

Blue Vase

18" x 24" oil on canvas
Private collection

A while back, one of my daughters presented Marilyn with this bouquet of flowers in the middle of winter. She placed them in the gallery, and the arrangement caught my eye time and again over the next few days. Marilyn also presented the couple who purchased the painting with the blue vase as a gift.

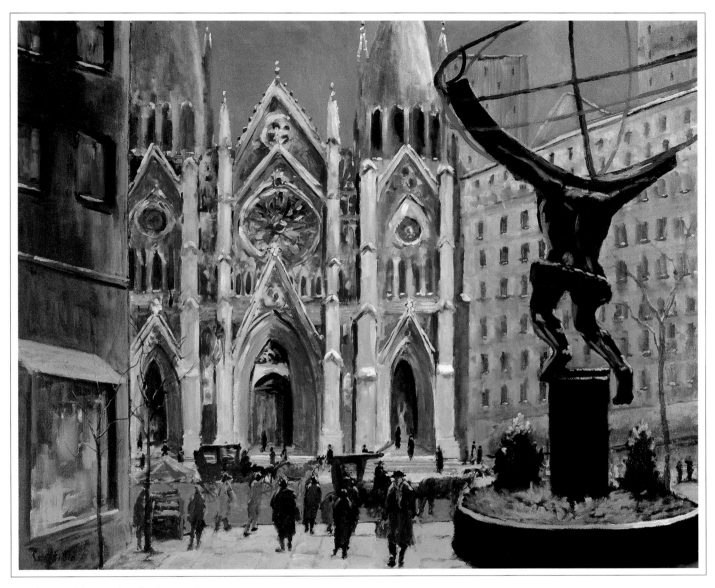

St. Patrick's Cathedral, NYC 30" x 40" oil on canvas

I used strong placement of light in this view of the cathedral, to accentuate its magnificent lines. The mass of the Atlas Statue in the foreground adds a powerful balance and contrast. Exaggerated perspective brings a feeling of depth, while the play of color on the stained glass windows adds to the composition.

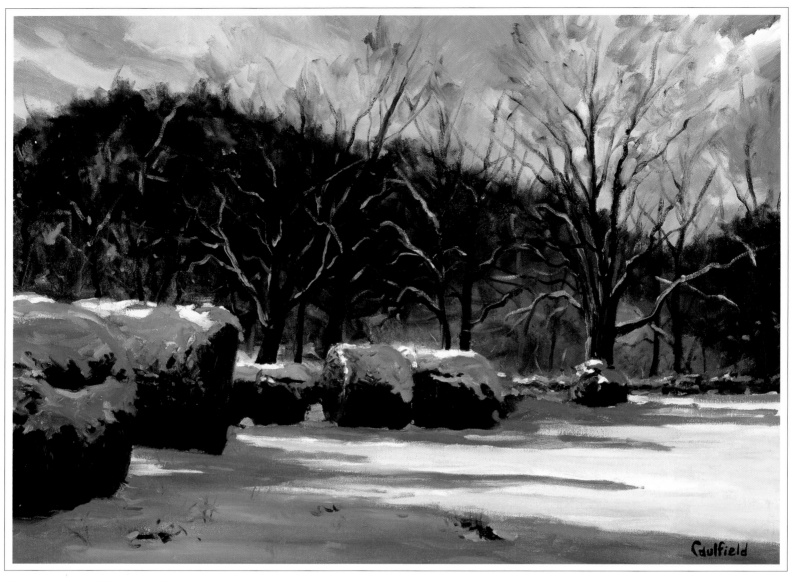

Haystacks In Winter 18" x 24" oil on canvas

Collection of Ann Liberatori

I came upon this scene while driving through Manchester, Vermont, and painted it on the spot. Looking into the sun, I added darker values in the background and reflected them in the haystacks. Cool, blue shadows flow across the foreground, highlighted with a mixture of Naples yellow and white. The echo of clouds in the distance emphasizes the haystacks as the painting's center of interest.

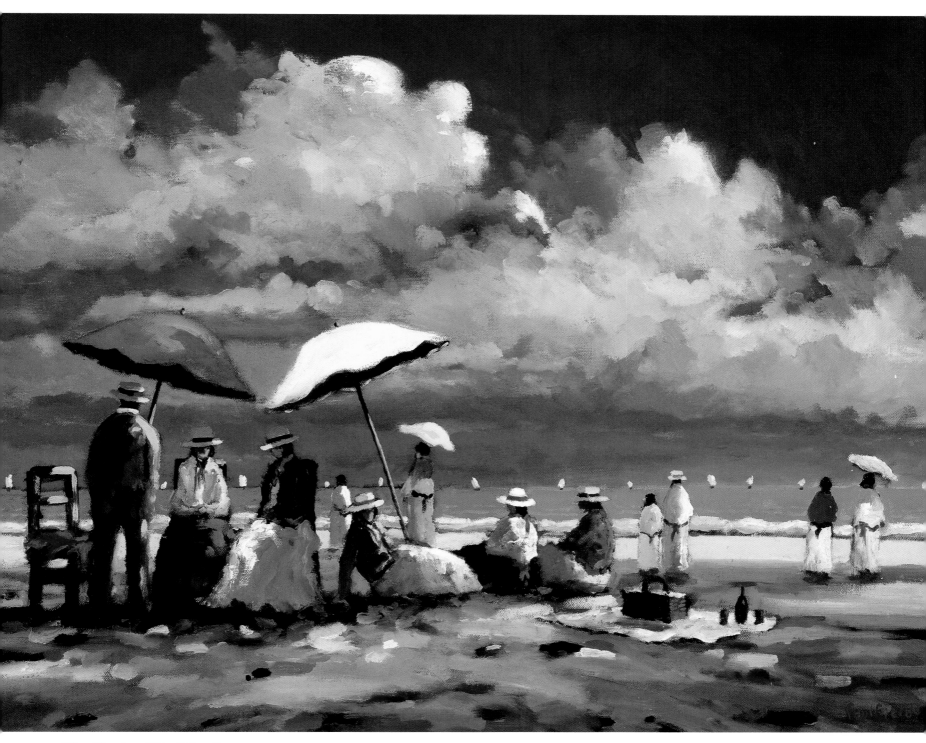

The Picnic 22" x 28" oil on canvas

Collection of Jean and Peter Helwing

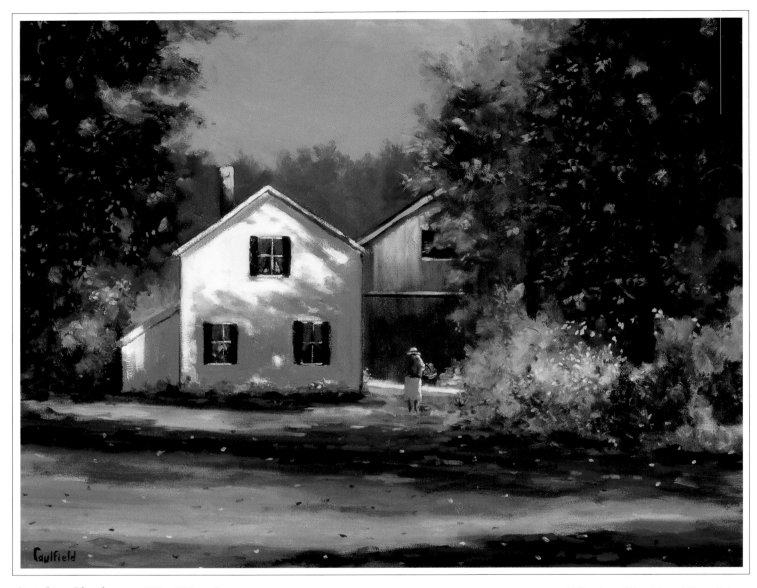

October Shadows 22" x 28" oil on canvas

Collection of Daniel and Kary Grimes

October in Vermont finds the days growing shorter as winter approaches. The sunlight itself seems colder. There's an old saying, "Vermont has four seasons and three of them are winter!" Here, the white house in the shadows is surrounded by dark colors. I've indicated the distant barn to lead the viewer into the painting, and developed the tree-filled area at right to emphasize a strong balance of color. Believing the painting needed one more center of interest, I added the old woman.

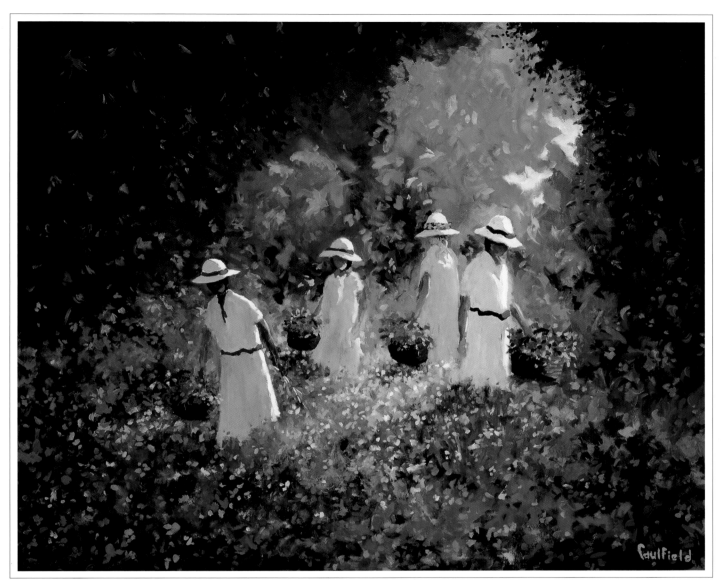

In The Garden 30" x 36" oil on canvas

Collection of Kim and Alan Rummelsburg

Here, warm rays of sunlight and strong coloration
set the tone for an early morning expedition to
pick flowers. The figures of the girls convey activ-
ity, while the numerous blossoms counterpoint
the greenery with a smattering of color.

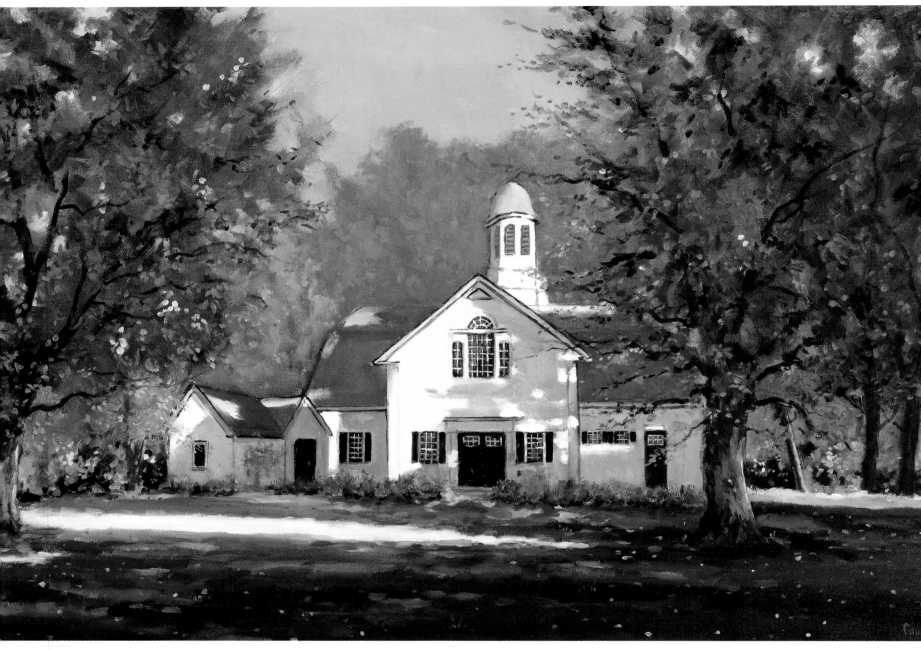

October Shadows, Woodstock 24" x 36" oil on canvas

Collection of Richard and Christine Spillane

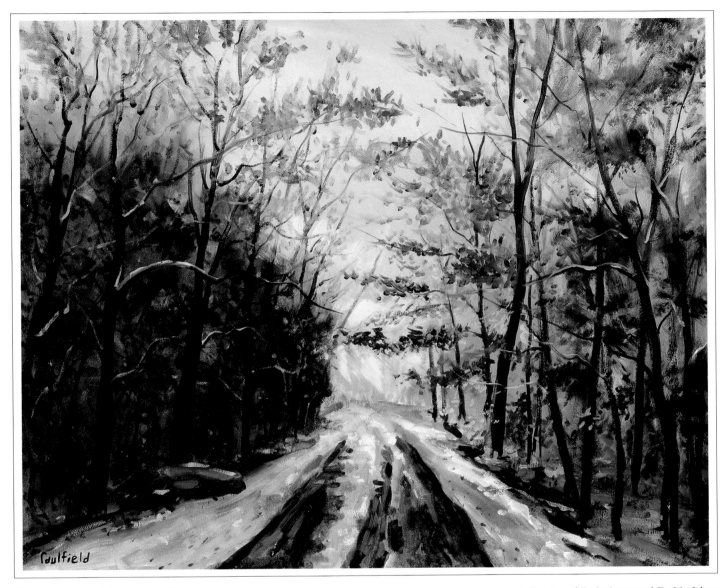

First Snow 20" x 24" oil on canvas

Collection of C. Swigart and D. Lindskog

Snow can come as early as October in Vermont. For this painting I went out at 6:00 AM, after one of these autumn storms. The fading autumn colors make for a striking contrast with the fresh-fallen snow. Carefully judging the scene's values, I laid in the early morning sky and first rays of sunlight, contrasting that with the darker foreground.

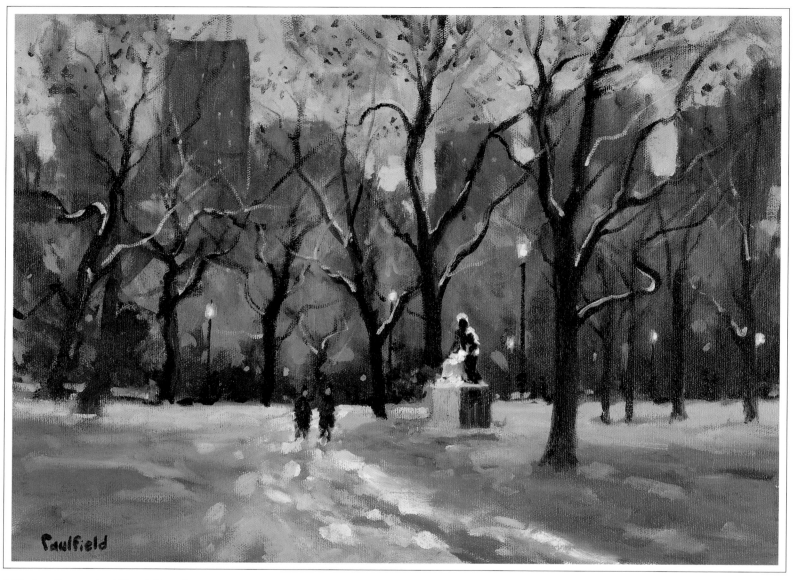

Winter Sunset 12" x 16" oil on canvas

Collection of the artist

A visit to New York is never complete without a walk through Central Park. What was a neglected urban blight twenty years ago, has been restored to the pastoral park its designers, Frederick Law Olmstead and Calvert Vaux, intended. Here, at sunset, the light reflecting off trees and snow-covered statues creates an interesting pattern.

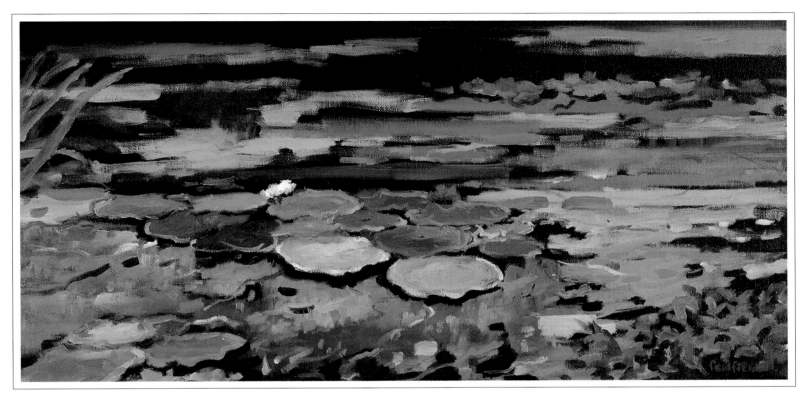

Water Lilies, Monet's Garden 12" x 24" oil on canvas

The last thought I'd have entertained upon visiting Claude Monet's sumptuous garden, would have been to do a painting of his lily pond. While fighting blindness near the end of his life, Monet completed a number of masterful versions of this subject. The garden is maintained as it was when he lived, and there was such an extraordinarily brilliant effect of light and color there that I felt inspired to do my own rendering.

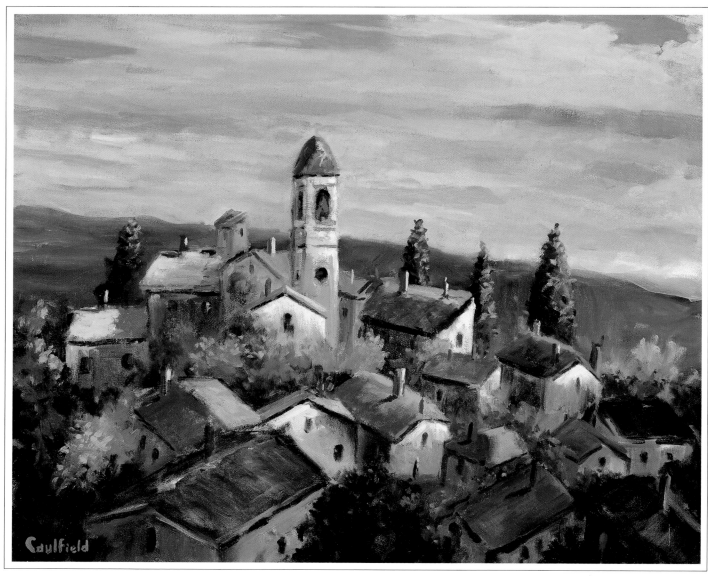

Rooftops of Eze, Provence 20" x 24" oil on canvas

Leaving Nice in the South of France, you'll soon come upon the mountaintop village of Eze. The view here was from my hotel window. The instant I looked out, I thought it would be a nice subject. The quiet sky doesn't clash with the interesting pattern of the tiled rooftops. Naples yellow and yellow ochre create highlights on the building, suggesting late afternoon.

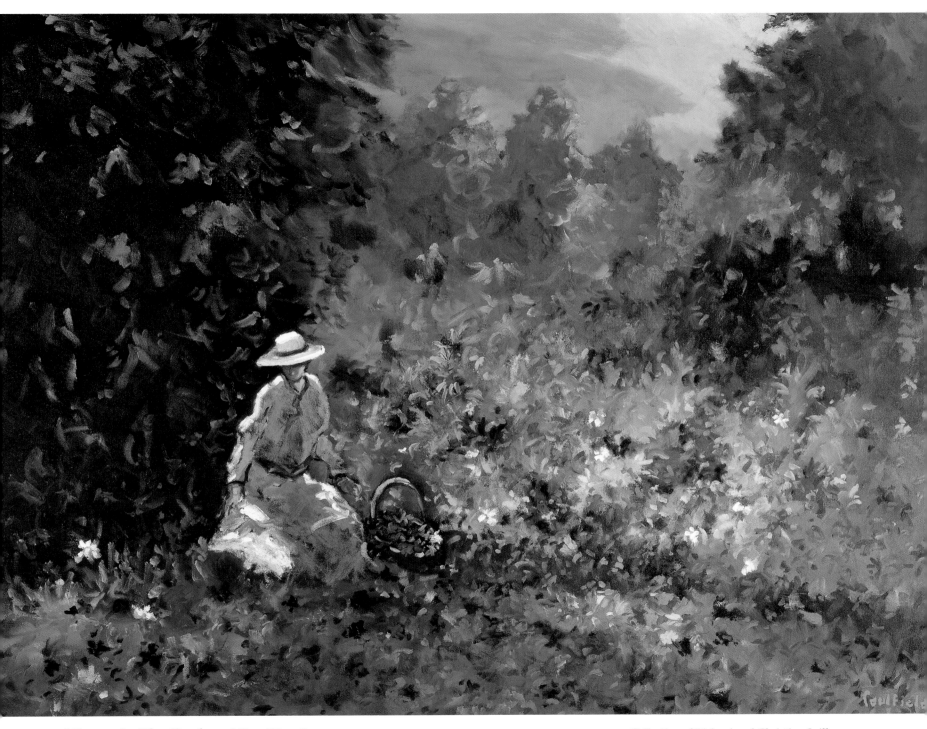

Woman In The Garden 30" x 40" oil on canvas *Collection of Richard and Christine Spillane*

53

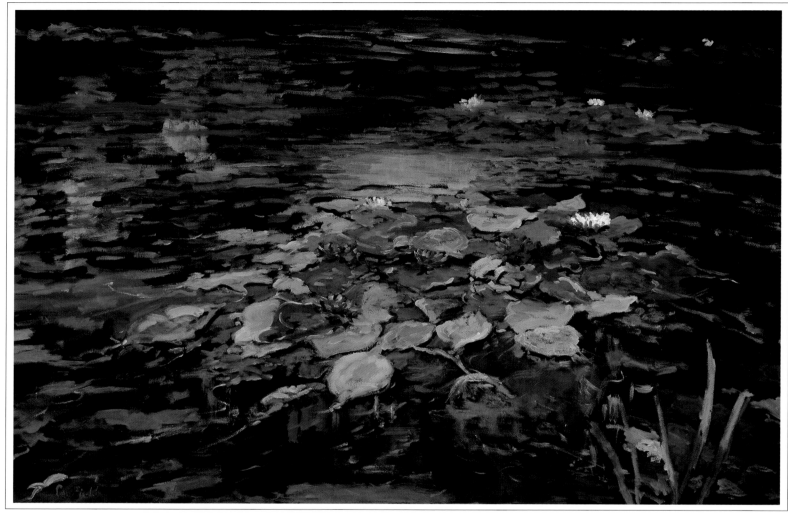

Afternoon Light, Giverney 24" x 36" oil on canvas

Collection of Mr. And Mrs. Dan Carlisle

Capturing one instant or aspect of nature was Monet's intention with his series of water lilies. Nature has often been the source of my inspiration as a painter. In this scene I tried to capture the lily ponds' fluidity exactly as it appeared that summer day. Though the lily pads with their vivid blossoms draw the eye as a focal point, that wasn't my intent. I wanted to recreate the sensation of light reflecting off the water's surface and diffracting through its depths.

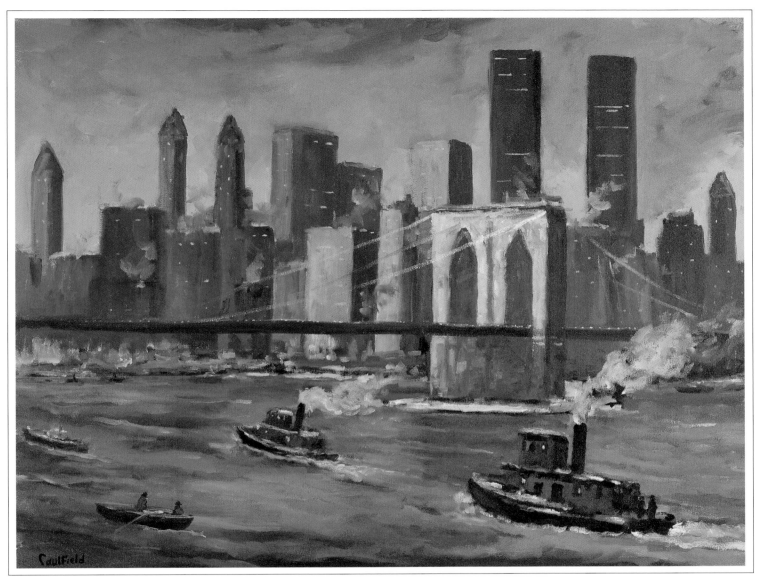

Tugboats, East River 22" x 28" oil on canvas

Collection of the artist

I often walk the streets of New York, visiting its various neighborhoods with my camera and sketchbook. I spotted these tugboats as I approached the Brooklyn Bridge one late afternoon. A gloomy winter sky recedes behind the monolithic skyscrapers, focusing attention on the bridge and boats.

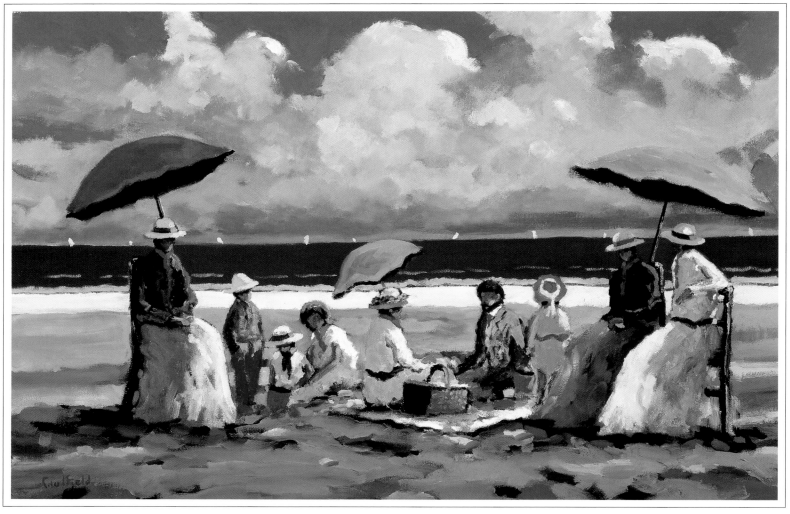

A Time To Remember 20" x 30" oil on canvas

In this beach scene, the warm light of the sand with its purple shadows, accents the luminous costumes of the figures under the umbrellas. A Florida sky with heavy clouds, and a dark viridian ocean, reflect the highlights in the foreground.

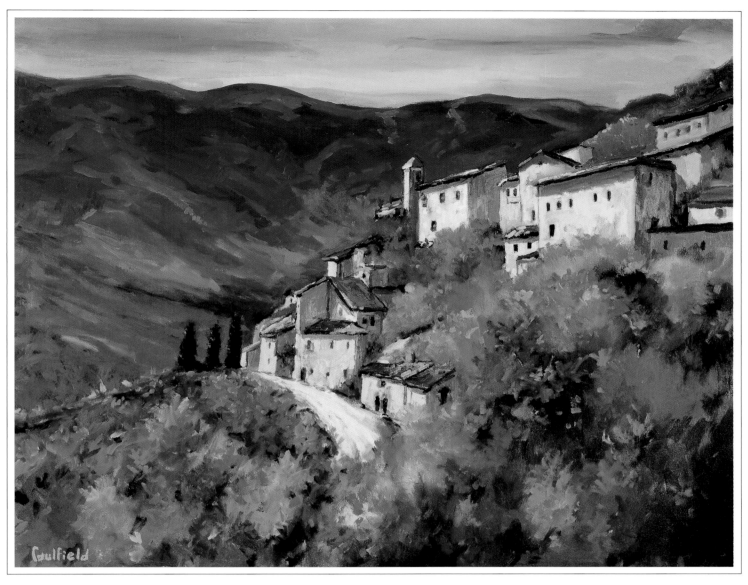

Village of Brante, Provence 24" x 30" oil on canvas

Collection of Richard and Toni Morena

Often in our travels, Marilyn and I drop our itinerary and head off down the road to find an adventure. Travelling abroad always brings the challenge of new subjects to paint. On one trip to Southern France, we came upon the quintessential Riviera village of Brante. In this scene, the line of trees leads your eye towards the sun-dappled buildings, broken only by the shadows of the rooftops. Strong mountains in the background add drama.

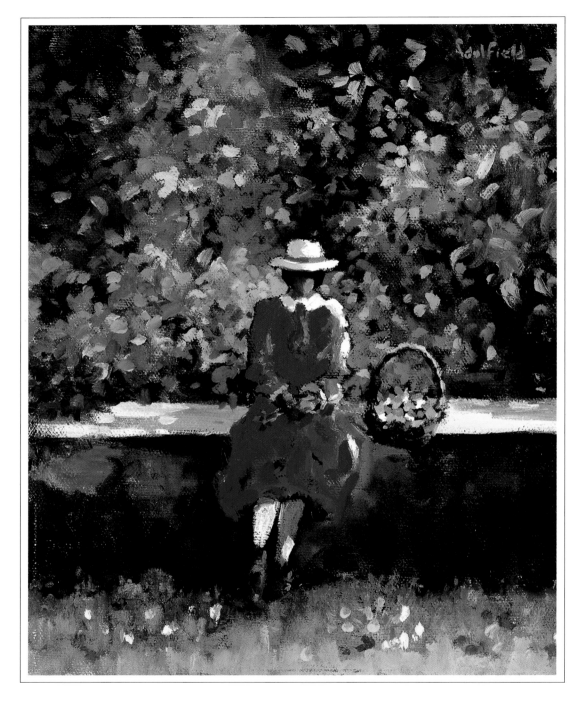

White Stockings

9" x 12" oil on canvas

Collection of Mr. Donald A. Powell, Esq.

A small childhood photograph of my mother-in-law, Ivadelle LeBlanc, had hung in our home for years. One day shortly after her death I made a sketch of it, thinking it could be the basis of a nice painting. Keeping the general pose, I changed the figure to that of a young adult. After completing the painting I felt it looked unfinished, and added the white stockings, which jump out at the viewer.

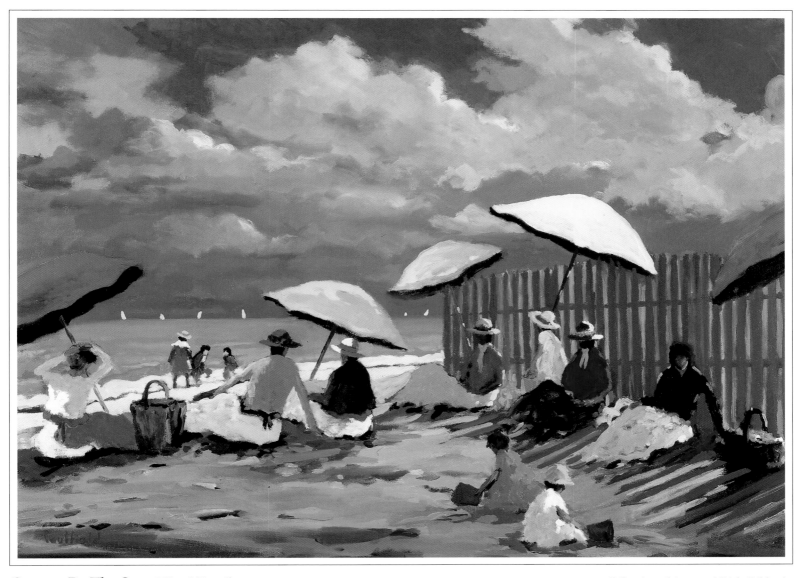

Cannes, By The Sea 22" x 30" oil on canvas

Collection of Amy and Rick Goldstein

While on a morning walk along the beach, I noticed this fence, which separates property lines in front of the Carlton Hotel. Though similar in their overall theme, my beach scenes are all quite different in terms of values and composition. I try to convey a sense of tranquility in all of them.

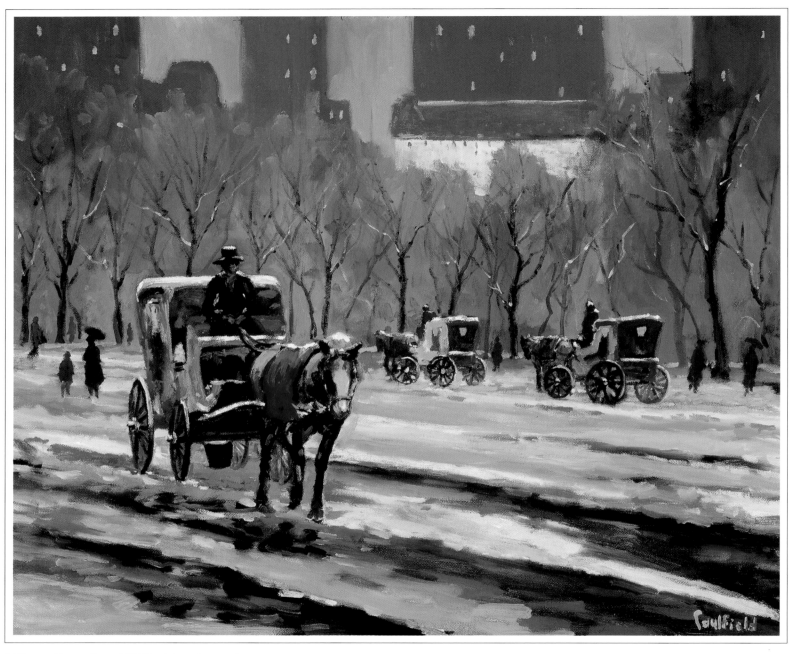

Winter Evening, NYC 20" x 24" oil on canvas

Collection of Marc and Tina Theroux

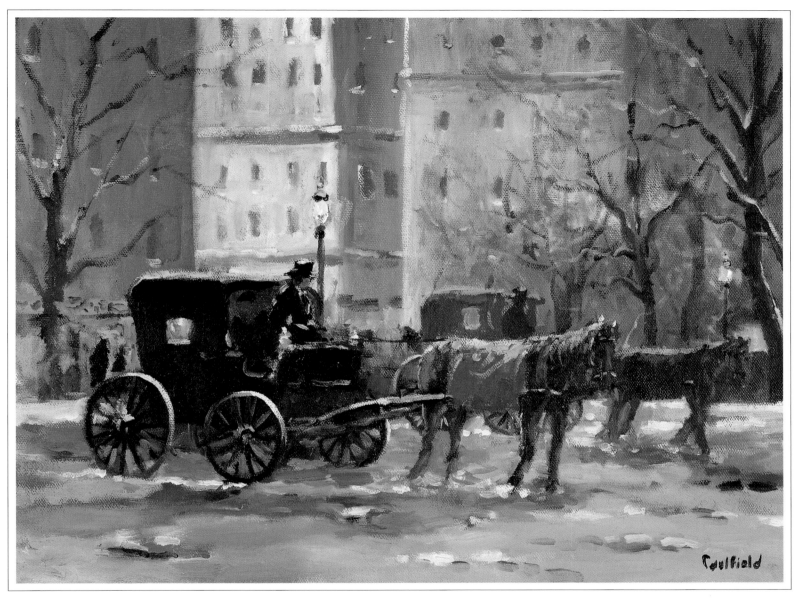

Lamplights, NYC 12" x 18" oil on canvas

Collection of Dr. and Mrs. Jeffrey Saltz

Cold is an ever-present fact for the winter months in the north, and I think this painting captures that feeling. This scene also conveys a sense of solitude, with the warmth of the streetlights receding as the horse-drawn cab heads off into Central Park.

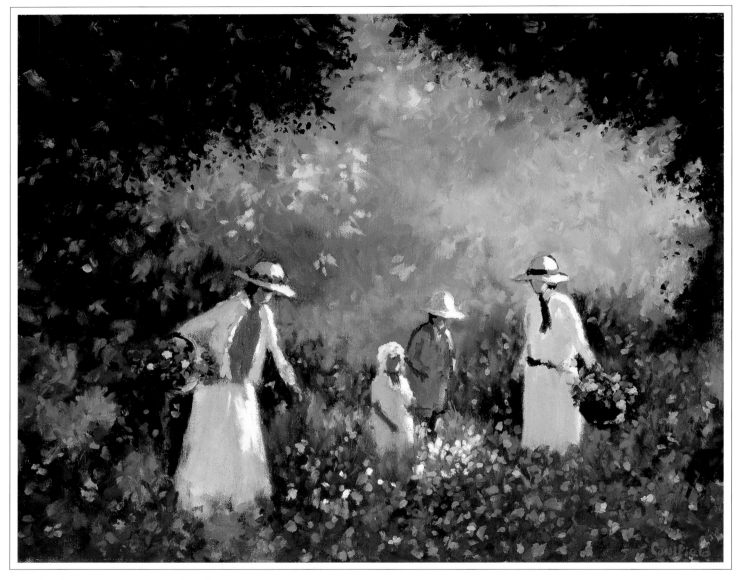

Tender Moments In The Garden 16" x 20" oil on canvas *Collection of Bruce and Barbara Ferguson*

During my first trip to visit Monet's home in the village of Giverney, I was impressed with the number of beautiful flower gardens in the surrounding countryside. This painting is the result of pastel sketches I did there. I think it captures the warmth and light of a spring day in full bloom.

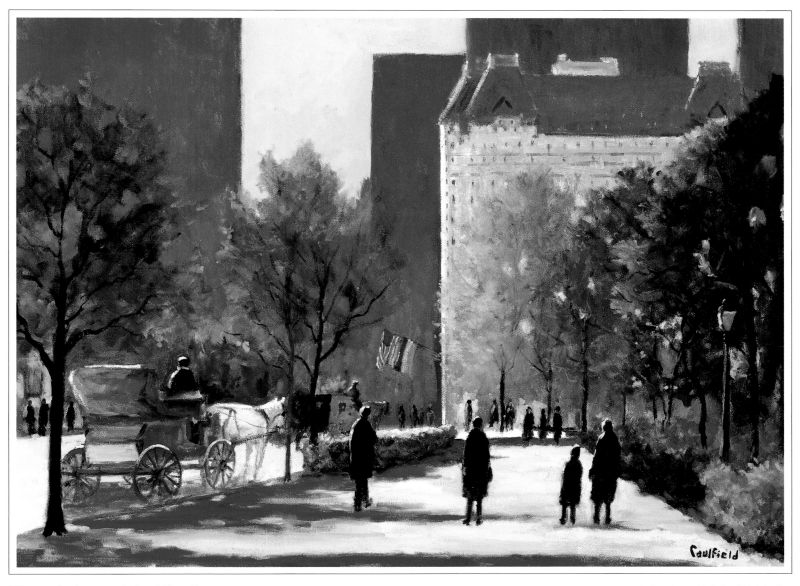

Plaza, Autumn 20" x 30" oil on canvas

Collection of Michael P. Morley

The dark shadings of the trees add a strong counterpoint to the pale walls of the Plaza, and the powerful, flat light of the scene. The painting's stark force is accentuated with long shadows, and by keeping detail on the carriage and the pedestrians to a minimum.

October Colors, Vermont

12" x 24" oil on canvas
Collection of Nick and Genese Bouchard

Many of the mountains surrounding Woodstock were denuded in the nineteenth century for logging and farming. This painting captures the energetic lines of some trees that have grown back, at a moment when their branches are filled with leaves of brilliant yellow and orange. The twisting limbs with their vertical thrust have a certain wild spirit, while the horizontal lines of the clouds add a pleasant counterpoint under an overcast sky.

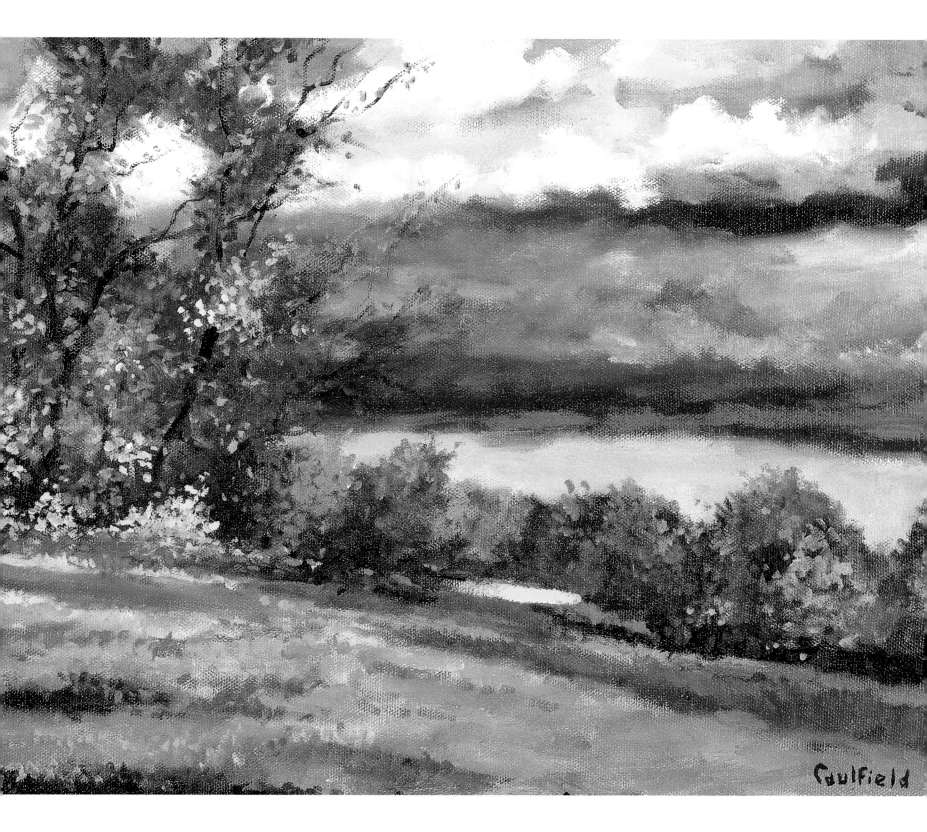

65

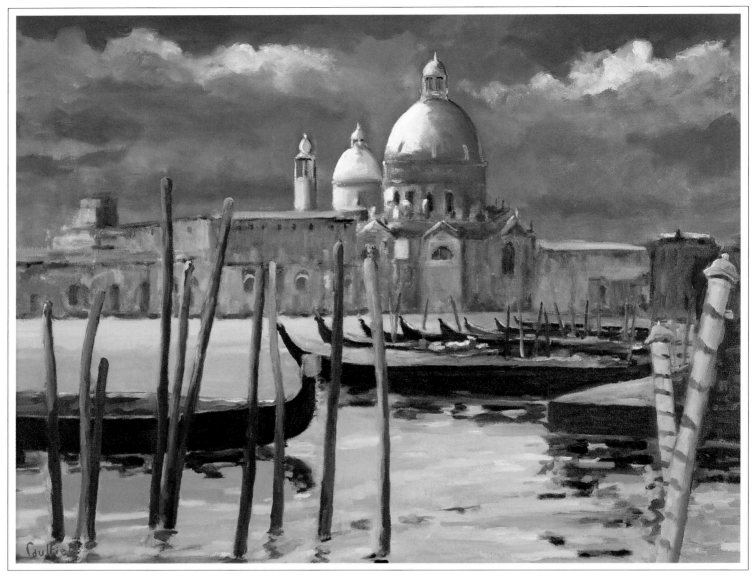

Santa Maria Della Salute, Venice 24" x 30" oil on canvas *Collection of Dr. and Mrs. Jeffrey Saltz*

This is my interpretation of one of the most popular landscape subjects of painters all over the world. I chose to use San Marco Square as my vantage point, looking across the wide harbor toward the Basilica. The dazzling natural light of Venice is reflected in the strong pinks and yellows in the background. The water's multiple shades of aqua-blue contrast with the cobalt blue sky and pink clouds.

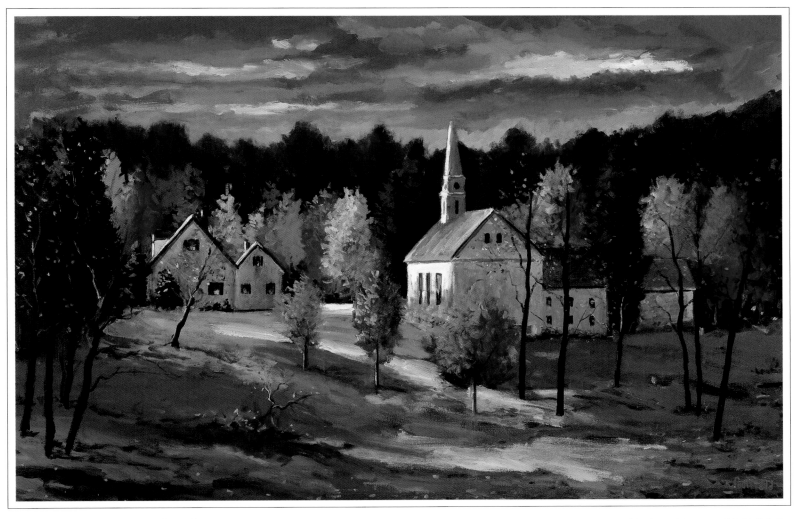

Vermont Village, Woodstock 24" x 36" oil on canvas

Collection of Anne and Jeff Wakelin

A New England autumn, with its vibrant, fall leaves and dark, stormy clouds, makes for a terrific conventional landscape. The church steeple was added. In actuality the church has a small dome. By casting everything in shadow except the church, I hoped to draw the viewer's attention through the scene, using a streak of Naples yellow, titanium white and Payne's gray.

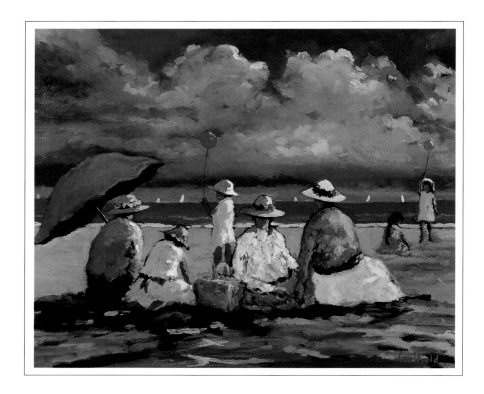

Sunday Afternoon
20" x 24" oil on canvas
Collection of the artist

Beach Day, July
14" x 18" oil on canvas
Collection of Carol C. Cacciamani

One day on the beach in Florida, I stopped to sketch a group of women because their configuration was interesting. A couple of them noticed me and voiced their disapproval, until I mentioned that I was an artist and probably would do a painting of them. When I told them that I was exhibiting in Palm Beach they became very excited at the prospect of being captured on canvas.

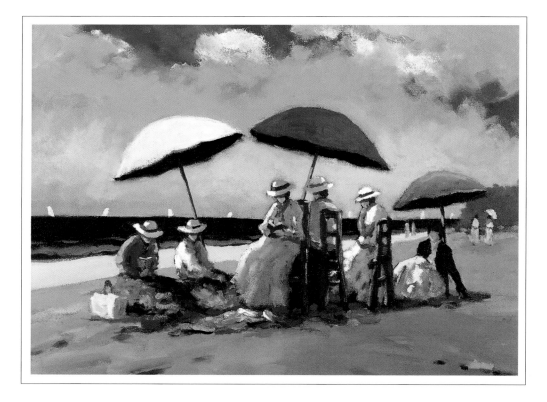

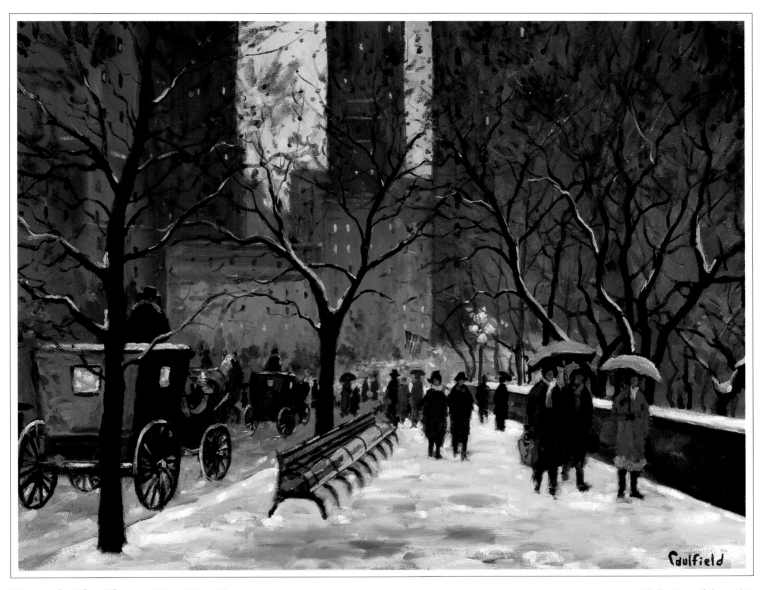

Towards The Plaza 22" x 28" oil on canvas

The area around 5th Avenue and 59th Street is an eternal favorite of mine. I've painted the Plaza and surrounding areas many times since 1978, at different times of day and during different seasons. Reproduced on my gallery brochure, this painting has become one of my most popular, and will soon appear in a limited edition lithograph.

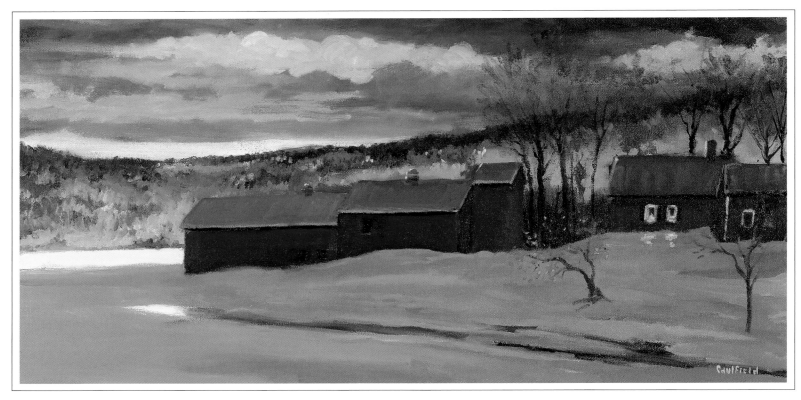

Jenni Farm, Vermont 12" x 24" oil on canvas

Collection of Anne and Jeff Wakelin

The Jenni Farm in Reading, Vermont is one of the most picturesque farms in New England, and among the most painted and photographed. One cold winter evening I noticed that the developing sunset looked quite colorful. My wife and I drove the eight miles to Reading to view it at the farm. We were richly rewarded with this scene. Even with a trained eye, creating a good painting takes a certain amount of luck, as evidenced here by the subdued and powerful effect of the light at sunset.

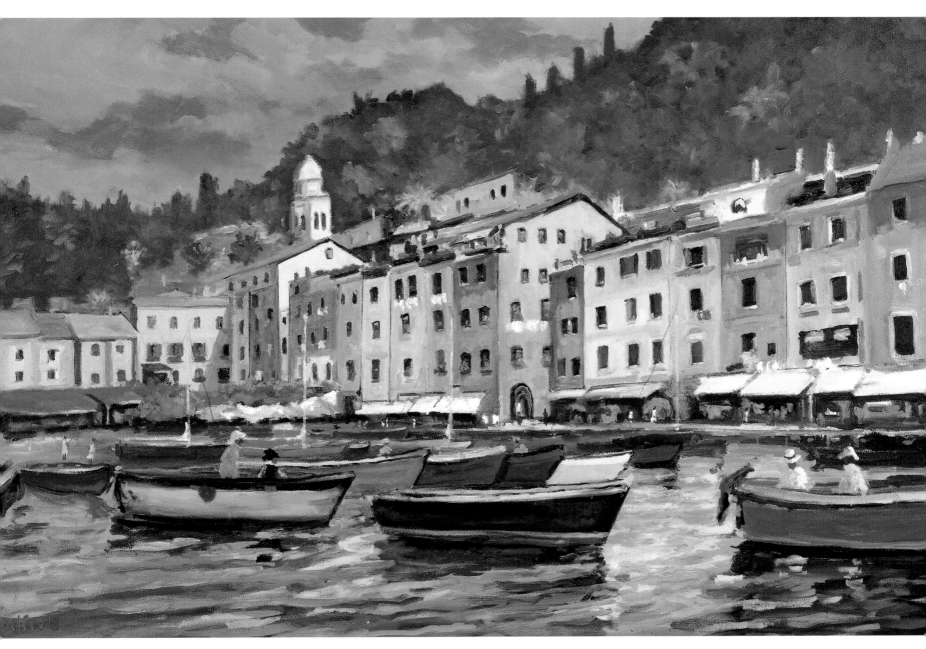

Portofino Harbor 24" x 36" oil on canvas

Collection of the artist

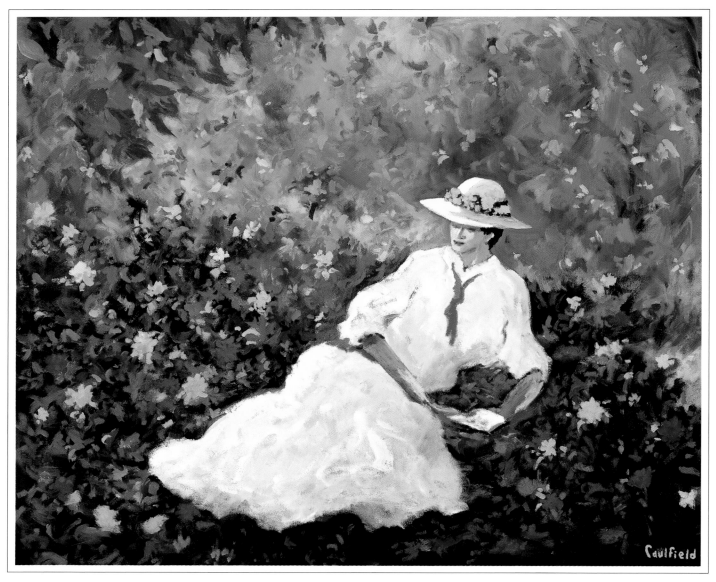

Lorelle's Garden 30" x 36" oil on canvas

This portrait of my daughter, Lorelle, is represen-
tational rather than an exact likeness. As I do with
many of my flower scenes, I painted the center of
interest lighter, with darker strokes representing
greenery and dashes of vibrant color adding to
the overall texture.

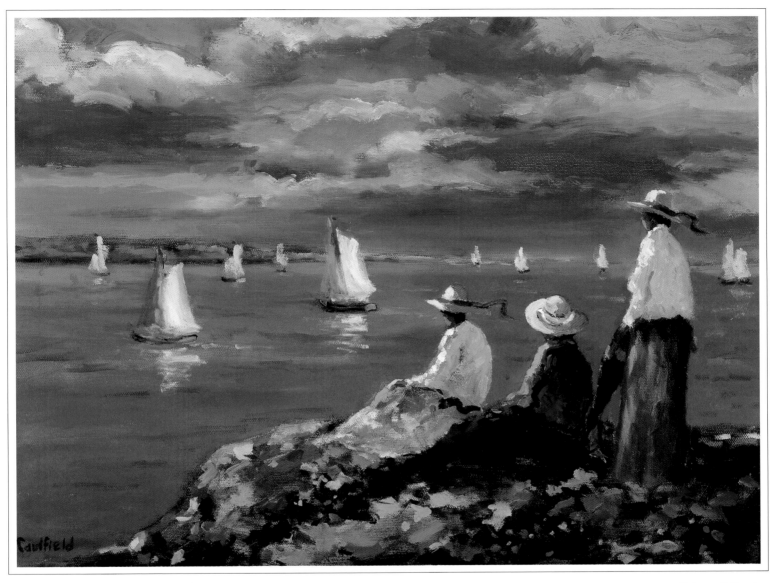

Cliffs of Cancale, Normandy 16" x 20" oil on canvas

Three women in bright dresses offer a pleasant contrast with the calm ocean and white sails in the distance. This area of France has provided me with numerous ideas for paintings. How many of us have sat in settings like this, admiring a similar view? Or would like to?

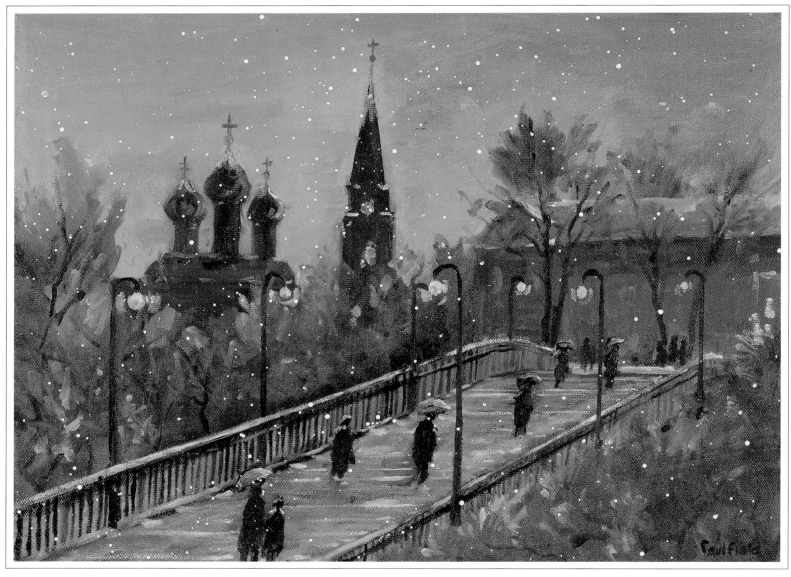

Moscow Bridge 12" x 16" oil on canvas

Collection of Marc Theroux

I used a limited palette in this winter scene, heavy on blues and burnt sienna. When Marilyn and I arrived for our first visit to Russia in December of 1998, there had been a record setting absence of snowfall. Luckily for us, for the next two weeks it did nothing but snow. Many sights that had been austere and gray were suddenly infused with snow-covered charm.

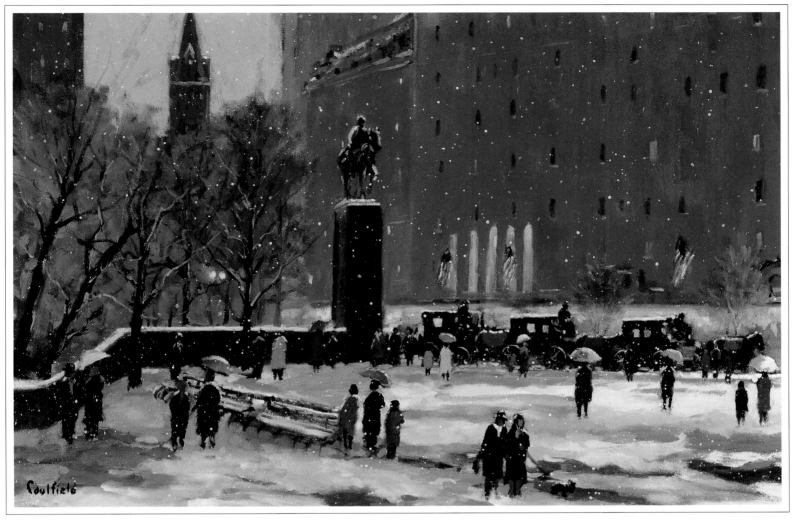

5:00 PM, Central Park South 20" x 30" oil on canvas

Collection of Richard and Deborah Donahue

This painting captures some of the street energy for which New York is famous. Cool winter colors suggesting an approaching winter night, are off-set by the warm light emanating from the windows across the street.

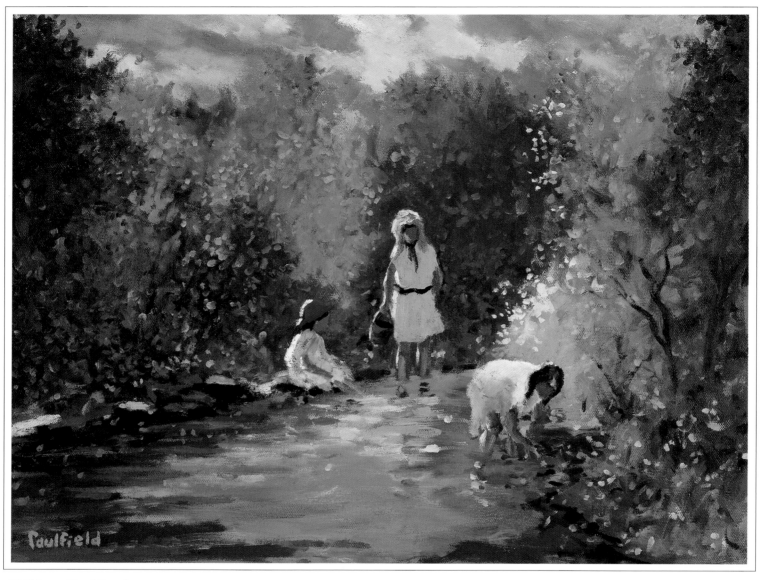

Children By The Stream 16" x 20" oil on canvas

Collection of the artist

This piece is highlighted with strong colors: cadmium yellow, yellow ochre and white. The muted background gives the painting and its subject, the children, a strong base, emphasizing their enjoyment of cool water on a warm day.

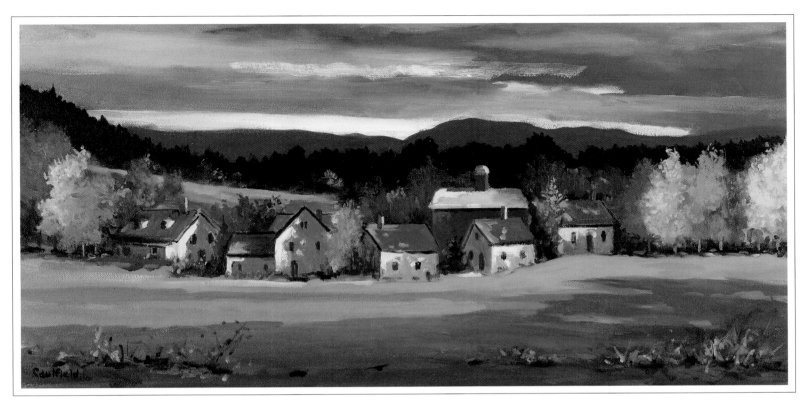

Vermont Village, Fall 12" x 24" oil on canvas

New England weather is notorious for its capriciousness. Though this might be bothersome for some people, it's wonderful for an artist. Clouds rolling in can transform a landscape, changing a somewhat flat scene to one alive with patterns of light and deep shadows.

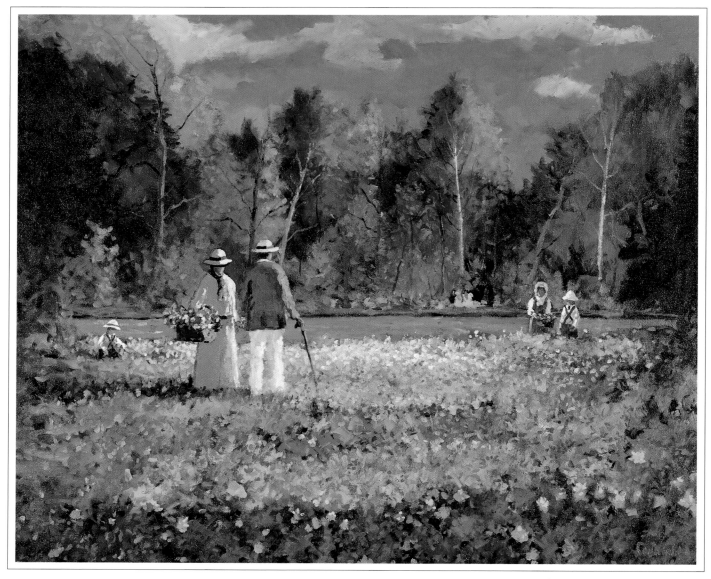

Field of Flowers 30" x 36" oil on canvas

Collection of Ann and Wayne Caulfield

It has become a tradition in my family to present my children with one of my paintings as one of their wedding gifts. My son Wayne married in 1988 and asked me to do a flower scene. This painting originally was planned with only the fig-ures of the man and woman, representing my son and his wife. By the time I got around to painting this romantic version of his family, he'd had three children, so I incorporated them into the work.

Provence Village, France 16" x 20" oil on canvas

This painting is a good example of how placement of light creates interest and adds drama to the elements of a scene. I emphasized the bright, sunlit buildings in the rear, to guide the viewer's eye toward the painting's center and around the haphazardly placed windows and door. The buildings in the foreground are rendered in cooler colors, adding dimension. Of secondary interest are the figures and the woman in the shadows.

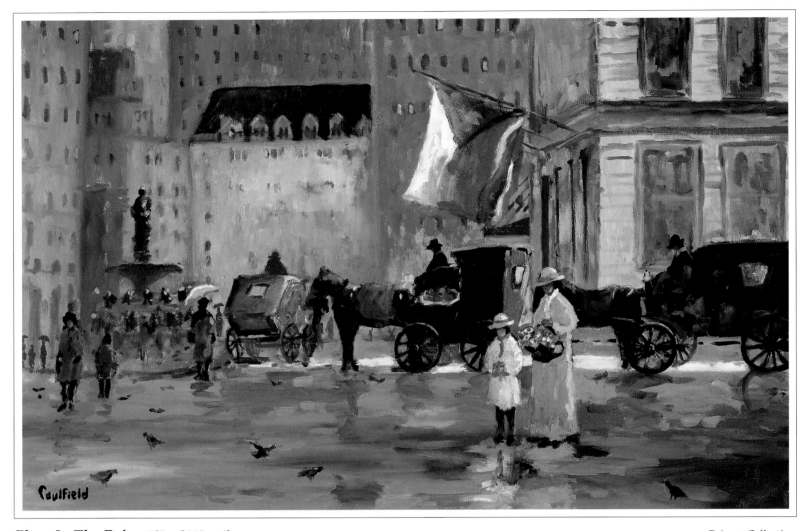

Plaza In The Rain 10" x 314" oil on canvas

I look for something different every time I paint the Plaza. The variations of this scene are endless, depending on the weather and time of day. What caught my eye here were the colorful flags flying over the entrance. I originally considered the painting complete with the horse and carriages, but felt it still needed something. As I sketched various ideas the woman and young girl carrying flowers appeared. They, along with a few other pedestrians on the rain-slicked streets, complete the composition.

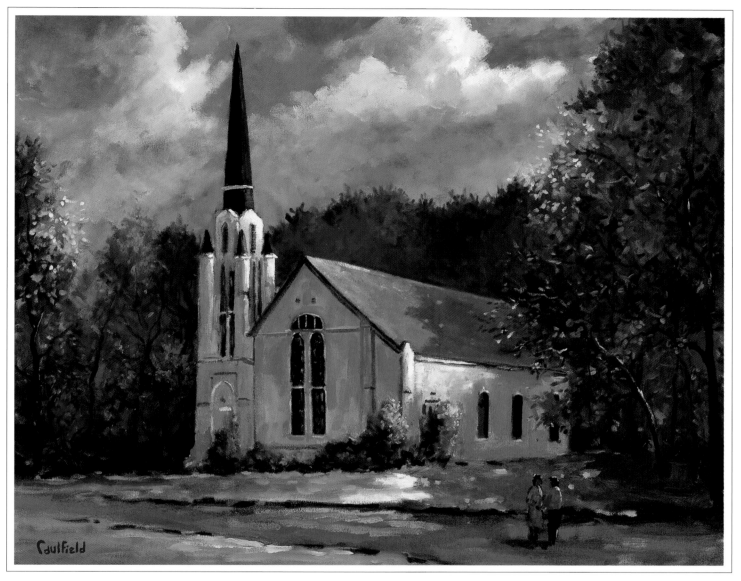

Quechee Village Church 22" x 28" oil on canvas

I painted this fall scene in early afternoon. What I found appealing was the interplay of light and shadow on this fine building. The sky was kept subdued so as not to detract from the tranquil atmosphere of the church. I reproduced the original colors of the scene except for adding darker trees in the background. The roof was softened with cobalt blue and a mixture of titanium white and Prussian blue. The strong highlight in the foreground leads your eye directly into the center of the work.

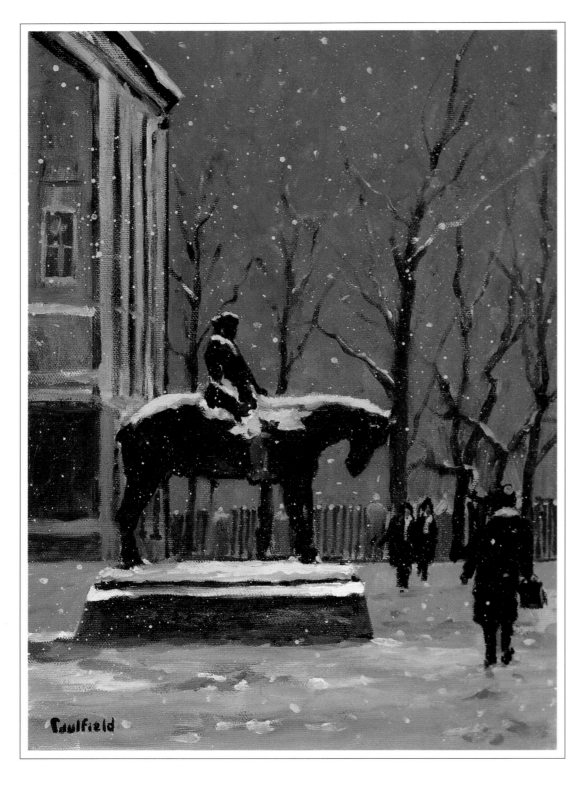

Caulfield

Statue of Ivan the Terrible, Saint Petersburg

10" x 14" oil on canvas
Private Collection

Marilyn and I visited Russia for the first time in early winter, 1998. This statue intrigued me because it survived the fate of many historic monuments during the Soviet era — being toppled and destroyed. In addition, it was mounted on a small base, rather than the usual tall, elaborate one. I took a few photos and made some sketches, and after my return home I set to work. I left the background very light and paid little attention to detail. The statue is the dominant source of interest, along with a few pedestrians. Of course, since it was Russia, snow was falling.

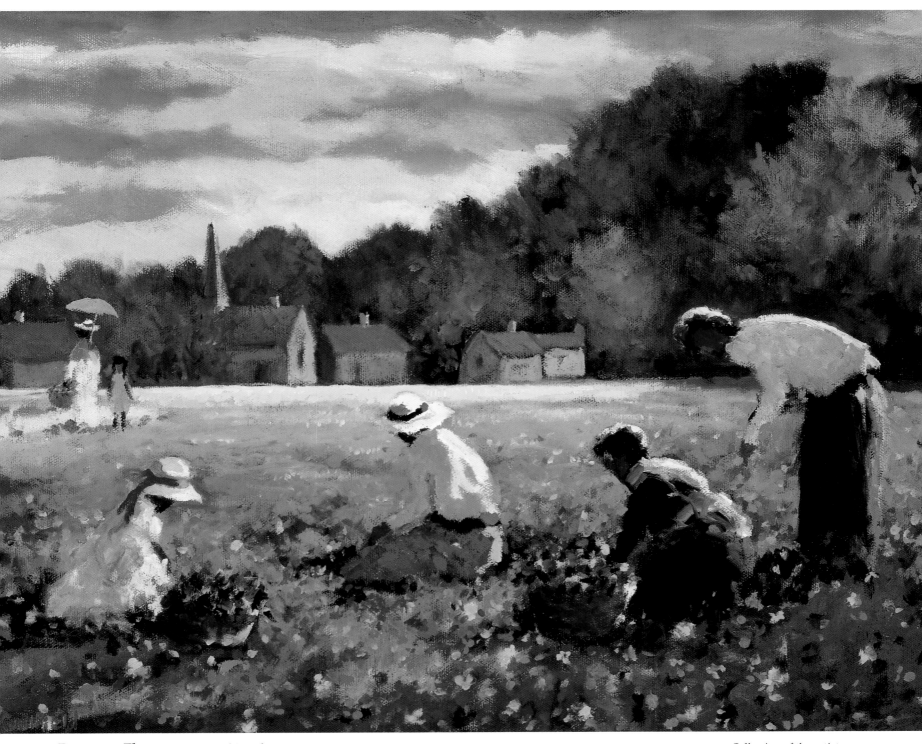

Provence Flowers 14" x 18" oil on canvas

Collection of the artist

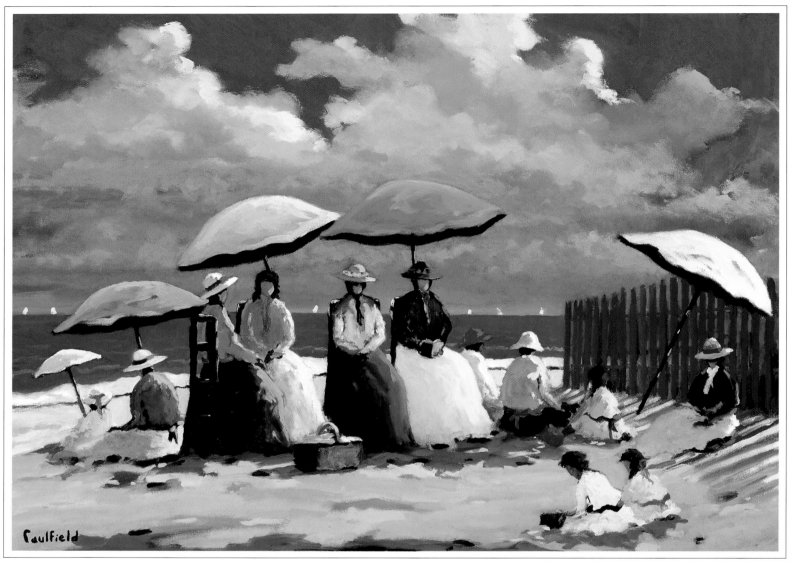

Beach Fence 20" x 30" oil on canvas

Collection of the artist

Since I first began doing them in the 1980s, my beach scenes have been among my most popular work. In this particular scene I was hoping to create a sense of serenity. Pink umbrellas contrast with the green. Billowing in the distance, the tone and radiant color of the clouds add form. Ladies in sunny dresses balance the blue-purple of the fence.

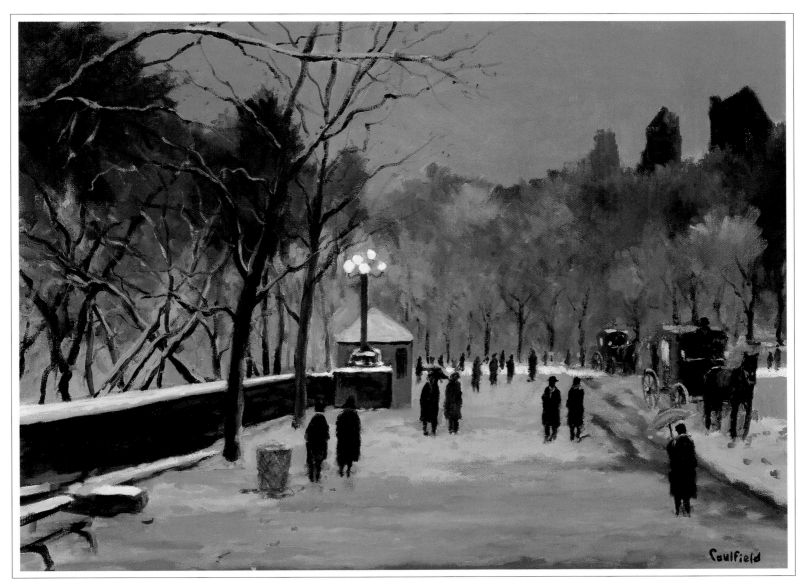

Lamp Light, Entrance to Central Park, NYC 18" x 24" oil on canvas

Collection of Richard and Toni Morena

Horse-drawn cabs are always present on 59th Street across from the Plaza. Here, light streaming through the center of the painting breaks the plane between the snow and trees. I added additional trees and people in various interesting forms to complete the overall atmosphere.

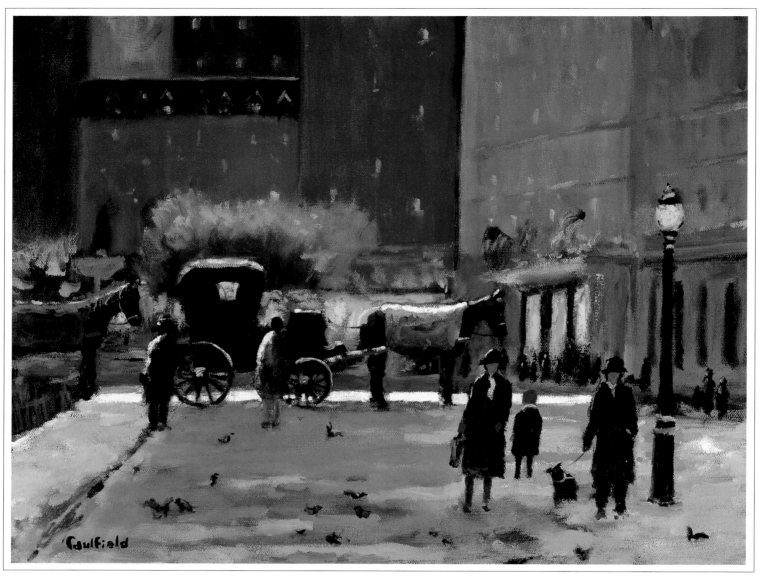

Plaza Evening, NYC 14" x 18" oil on canvas

The warm glow of light in the near distance accentuates the horse and carriage as the dominant force in this painting. Concerned with the sensory experience of color, I darkened the foreground. The dark colors reinforce the lighter ones.

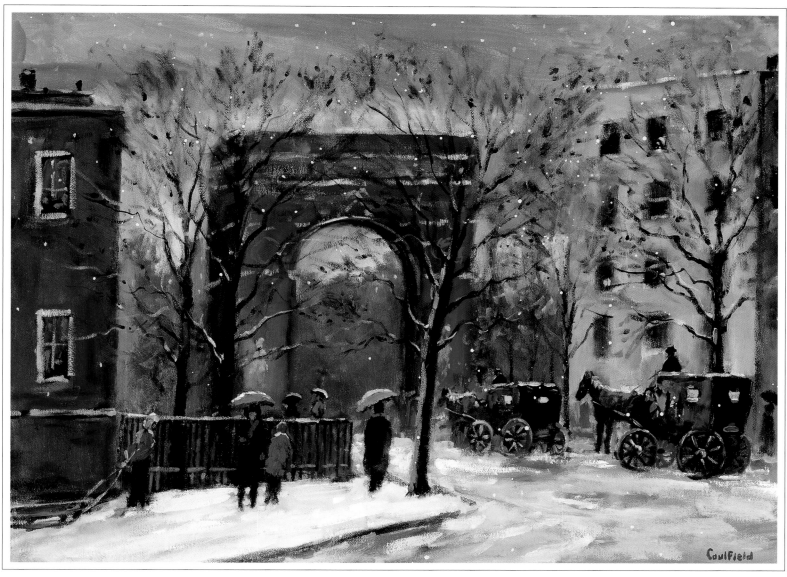

Washington Square, NYC 18" x 24" oil on canvas

Collection of Elizabeth W. Winder and Reynolds E. Moulton, Jr.

People often ask why I rarely include automobiles in my paintings The most likely reason is that I'm more interested in capturing a certain mood than recreating a scene literally. I have done many paintings of Washington Square through the years, but this one in winter, with its snow effect, is one of my favorites.

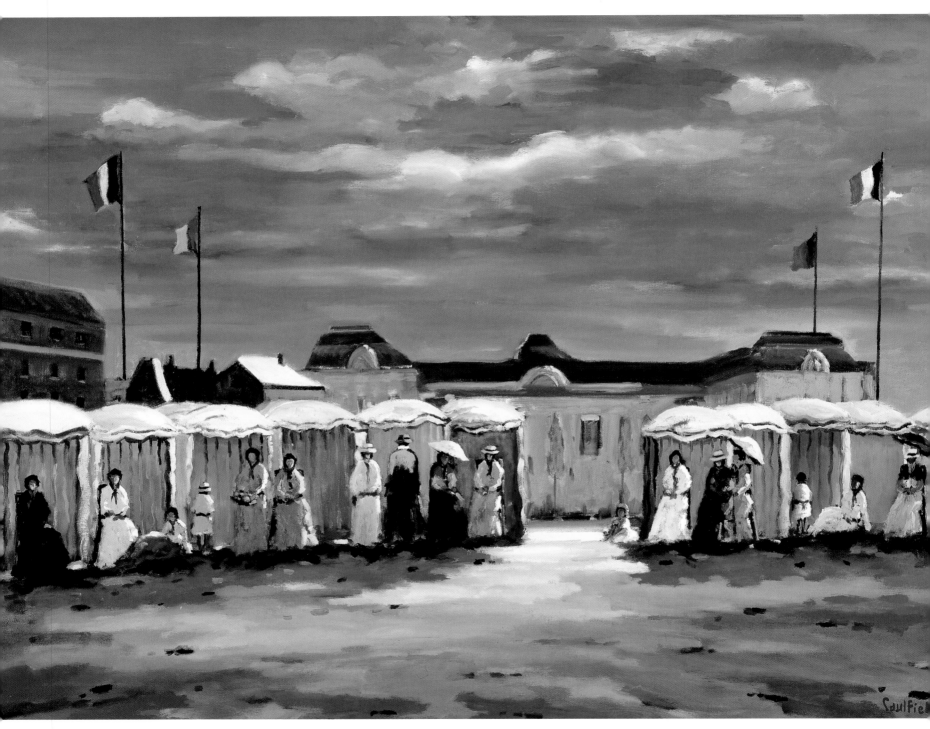

Deauville, France 30" x 40" oil on canvas

Collection of the artist

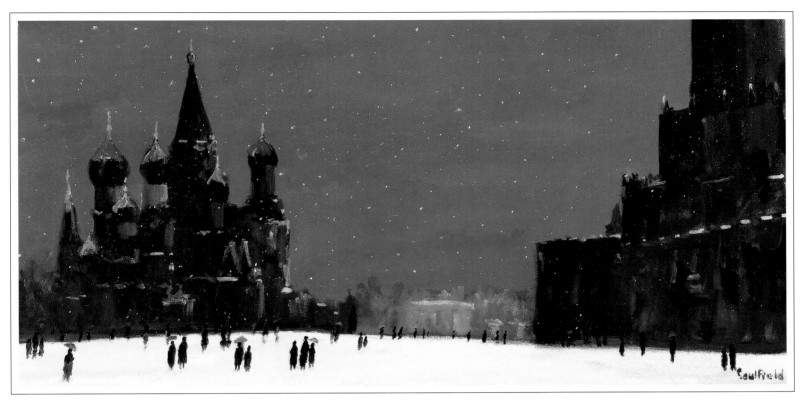

St. Basil's, Moscow- Dusk 12" x 24" oil on canvas

Collection of Mr. and Mrs. Daniel J. Gregory

Following a late dinner one snowy night in Russia, our tour guide asked if we'd be interested in seeing St. Basil's in Red Square. Marilyn and I were thrilled. Going there would allow me to do a night scene of this majestic and mysterious building. Once back at my studio, I relied on sketches and photos as I laid in a dark purple sky. The church and a corner of the Kremlin are modulated to a very dark value using alizarin crimson, burnt umber and a dark purple. Titanium white and Prussian blue are mixed for the snow, with highlights on both buildings breaking the monotony of the solid mass.

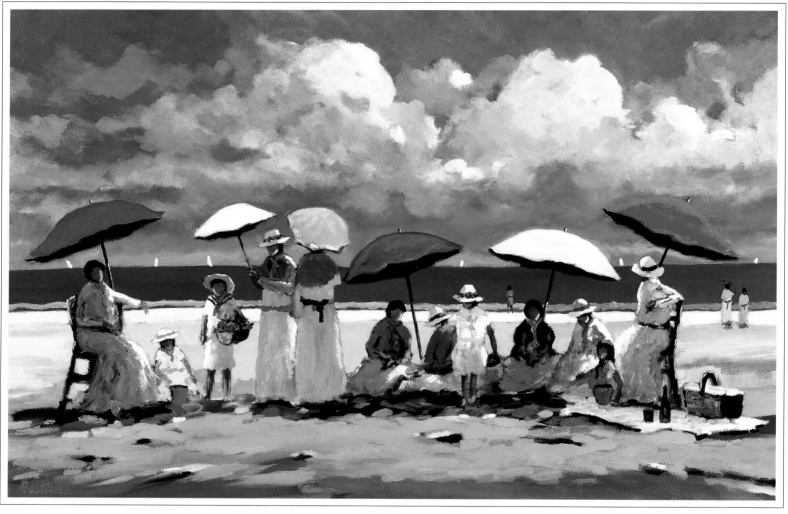

Summer Beach Day 24" x 36" oil on canvas

Collection of the artist

The skies in Vermont are often gray and overcast. You rarely see the fantastic cloud formations found in lower latitudes such as Florida or the Mediterranean. I often visit the beach in Florida and make quick sketches of groups of people. Later, in my studio, I use these as a groundwork for my beach scenes.

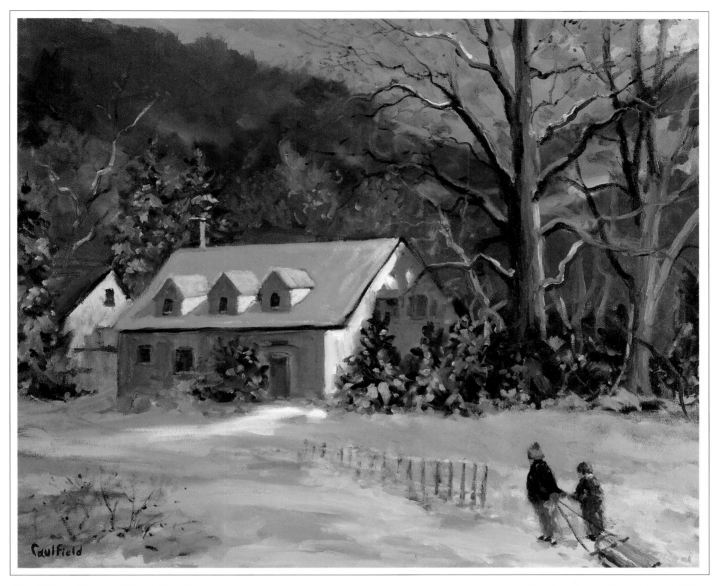

Sledding Day 20" x 24" oil on canvas

Collection of Dorothy and Donald Hunt

As a boy, one of my favorite pastimes was sledding. This theme occasionally appears in my work. My intention in this scene was to create the feeling of a return home on a freezing winter's day. The mountain in the background was done with light purple and burnt sienna. The house adds interest with a cobalt blue roof, highlighted with Naples yellow and titanium white. The powerful trees dominating the house were done in burnt umber and Venetian red. The figures of the children are the focal point and I loaded them with color. The hint of a broken fence draws the viewer's eye deep into the painting.

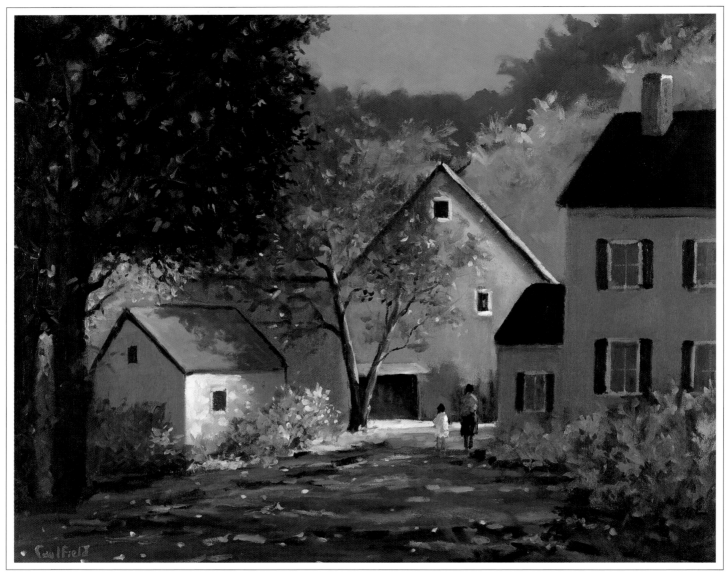

Autumn Light 20" x 24" oil on canvas

Collection of Dr. Cynthia Mann and Sostena Romano

This painting is a good example of a New England fall day. A late afternoon sun illuminates the high key colors of the barn. The adjoining shed provides valuable dark shadows in the foreground, guiding the viewer's eye toward the center of interest: a mother and daughter out for a walk.

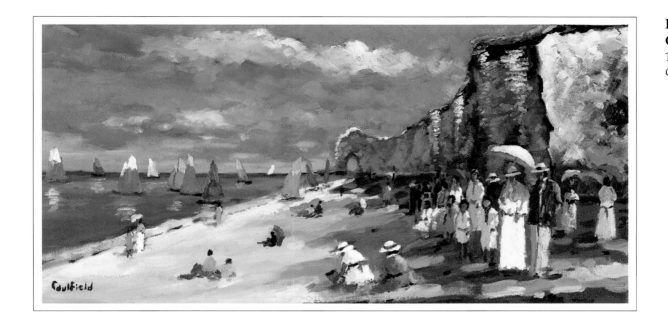

Regatta, Étretat Cliffs, France
12" x 24" oil on canvas
Collection of the artist

Étretat Cliffs, France
18" x 24" oil on canvas
Collection of the artist

Over the years I've done more than twenty paintings of this village in Normandy. Its jagged cliffs have attracted many of the great French artists. In this scene the cool colors of the cliffs, juxtaposed against the warmer tones of the sand, are highlighted with the colorful figures of people and beach umbrellas. As usual, I completed the scene with sailboats in the distance.

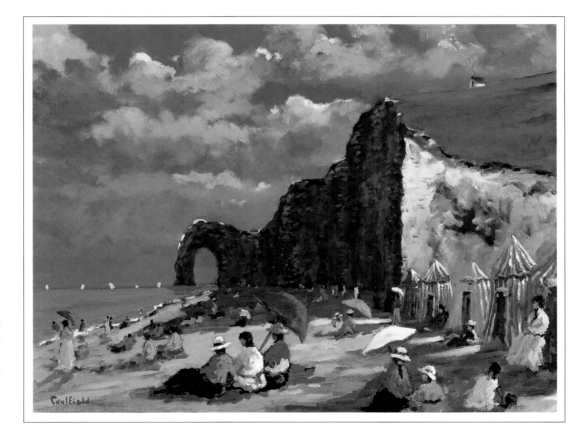

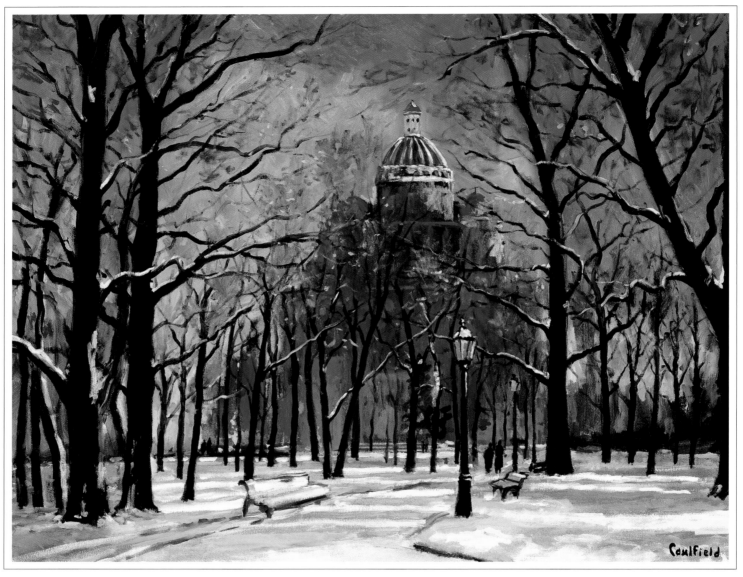

Saint Isaac's Cathedral, St. Petersburg 24" x 30" oil on canvas *Collection of Dr. Michael J. Ringle*

The former Tsarist capital of Russia, Saint Petersburg, boasts some of the finest architecture in the world. I went for a broad effect in the elements of the scene, keeping the sky simple with a mixture of cerulean blue, Prussian blue and titanium white. A burst of orange captures the fading sun at the horizon line. Dark purple was used for the cathedral, with highlights on the dome. Bare winter trees of burnt umber and Prussian blue, with snow-covered branches casting pale blue shadows, add a highlight.

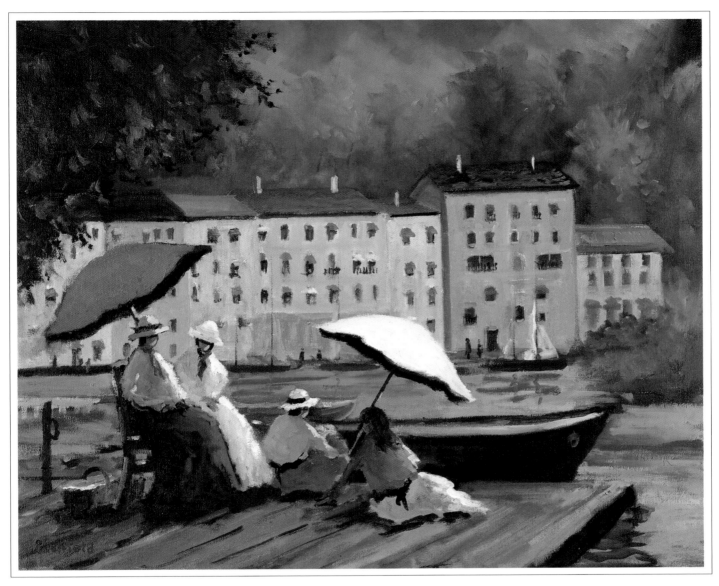

Rapallo Morning, Italy 20" x 24" oil on canvas

Collection of the artist

While on a recent trip to the Italian Riviera, I came upon a group of women picnicking on a dock. This became the genesis for this scene. The distant buildings were done in yellow ochre, burnt sienna and Naples yellow. The bright tiled roofs are common in this area. Umbrellas were my addition, and along with the boat of Prussian blue, complete the overall design.

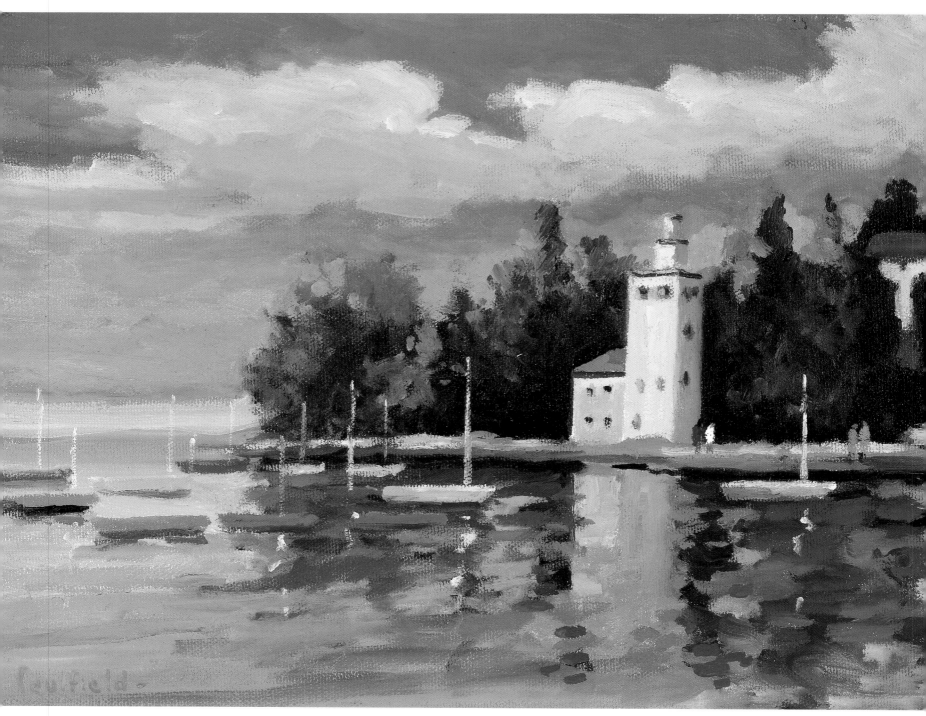

Rapallo, Italy 9" x 12" oil on canvas

Collection of Katherine R. Davisson

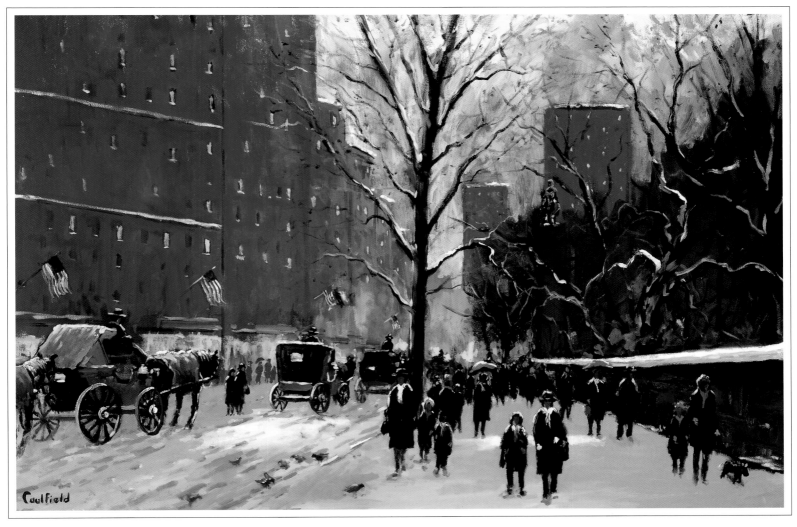

Winter Evening, New York City 24" x 36" oil on canvas

I think this painting captures the atmosphere of the city on a winter evening, with its bustle of traffic and fast-walking pedestrians. The wall surrounding Central Park leads the viewer's eye into the painting's center. In the distance the setting sun is represented with a mixture of flesh tones and titanium white. Various shades of purple represent the buildings. Note the balance of the trees; the lone tree in the center is contrasted with a number of much darker trees in the park.

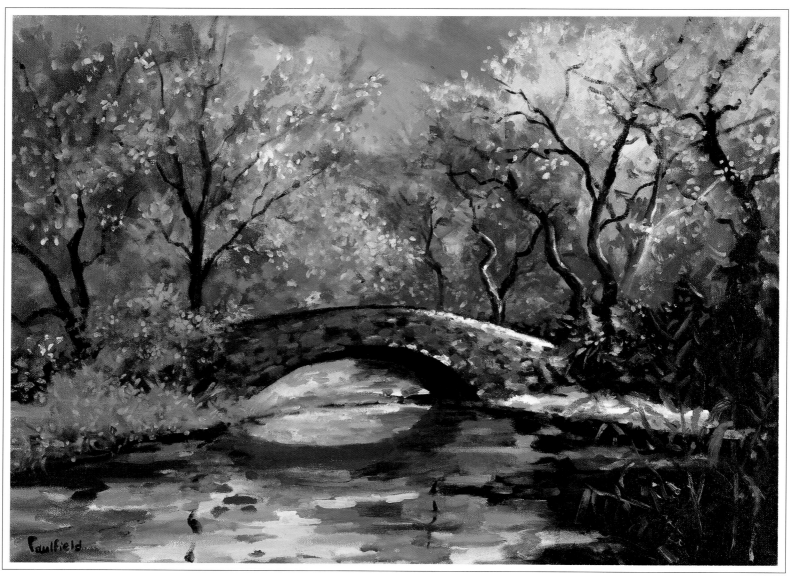

October Bridge 18" x 24" oil on canvas

Collection of the artist

This bridge is located near the Wollman skating rink in Central Park, and I've painted it in every season. I wanted to keep the viewer's attention on the bridge, by surrounding it with brilliantly colored autumn foliage. Note the shadows and reflections of colored trees in the foreground, which break up the blue mass of the water.

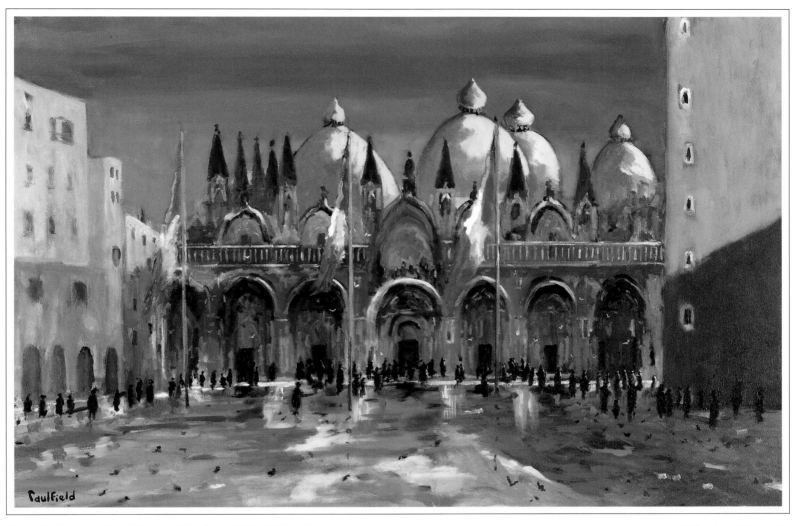

Flood, Piazza San Marco, Venice 24" x 36" oil on canvas

Collection of the artist

The piazza floods frequently, causing havoc for tourists but also reflecting a riot of color and light. By casting the foreground in shadow, I was able to highlight the ornate Basilica of San Marco in the background The three flags supply additional contrasting color and movement.

This painting recently received "The Award of Excellence" for best landscape from *Art Trends* magazine Gallery Choice awards for year 2000.

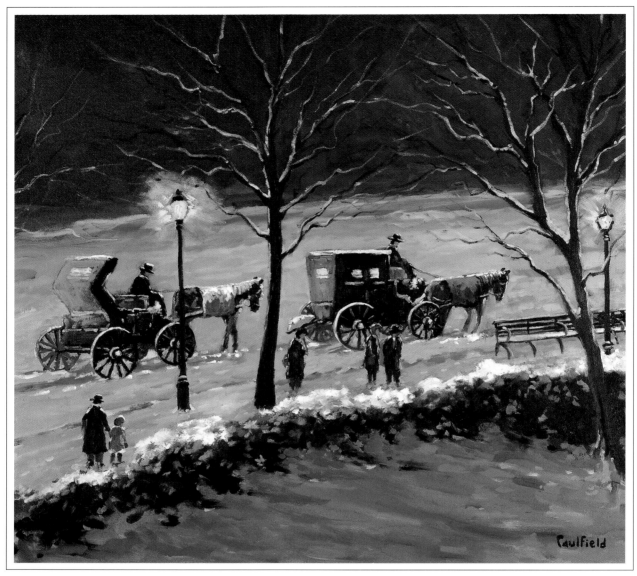

Carriage Ride, NYC 23" x 25" oil on canvas *Collection of the artist*

In this painting I wanted to keep the field of interest on the horse-drawn cabs, without the familiar cityscape in the background. Preliminary sketches were made on a small hill in Central Park in the fading afternoon hours. I set the scene at twilight, with the streetlamps aglow for atmospheric effect.

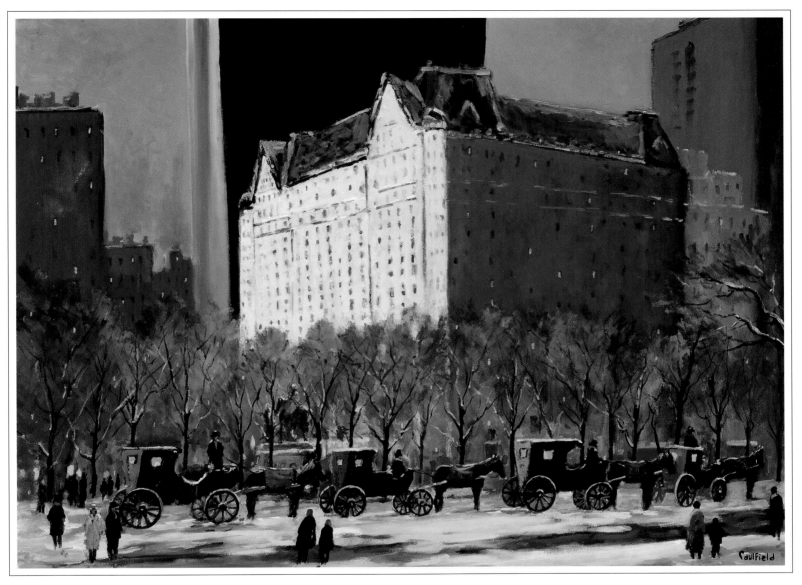

Late Afternoon, The Plaza, NYC 30" x 40" oil on canvas

Collection of the artist

The Plaza hotel on 5th Avenue and 59th Street is still one of the grandest hotels in the world. I always find inspiration in its majestic facade: a masterpiece of simplicity with hints of French Renaissance styling. The Plaza is one of my favorite subjects to paint. Here I surrounded it with shades of light and dark purple. The ever-present horse and carriages convey a sense of motion while the hotel's soaring white walls move forward toward the viewer. The Plaza has displayed my reproductions in their suites since 1977.

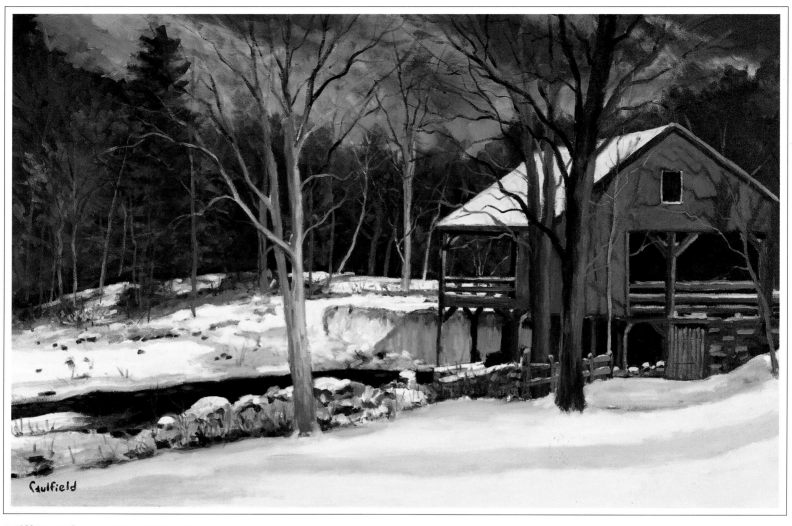

Mill In Winter 24" x 36" oil on canvas

This mill is located on a small waterfall in Weston, Vermont. The color harmonies of the mill are reflected in the trees and brush poking through the snow. A subtle play of fading afternoon light accentuates the contrasts of white snow, distant evergreens, and a stormy sky.

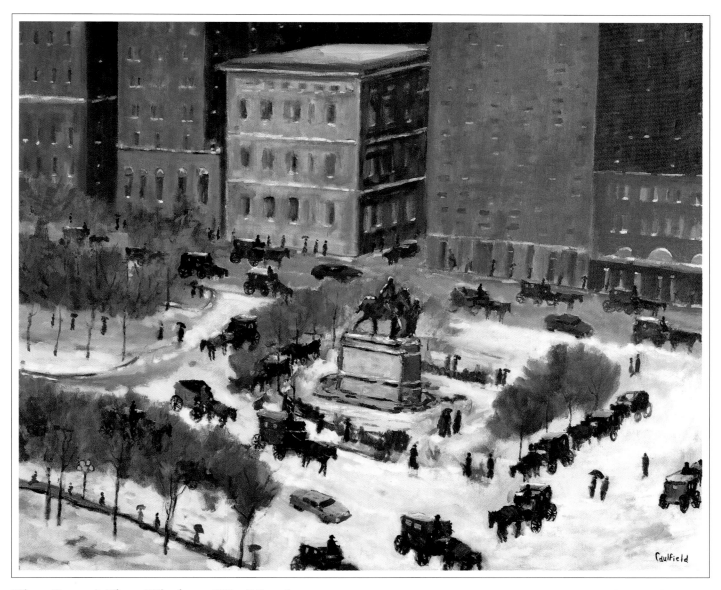

View From A Plaza Window 30" x 36" oil on canvas *Collection of the artist*

I greatly admire the equestrian statue of General Sherman by Augustus St. Gaudens which stands across from the Plaza. The horse-drawn cabs predominate at this location and I included a few cars and taxicabs as well. While checking in to the Plaza this particular time, I explained that I was an artist and interested in doing a scene of this statue from a hotel window. I set up my easel, and as I looked out on the scene, I thought about what the great Impressionist painter, Camille Pisarro, must have felt when he painted so many scenes from hotel windows towards the end of his life.

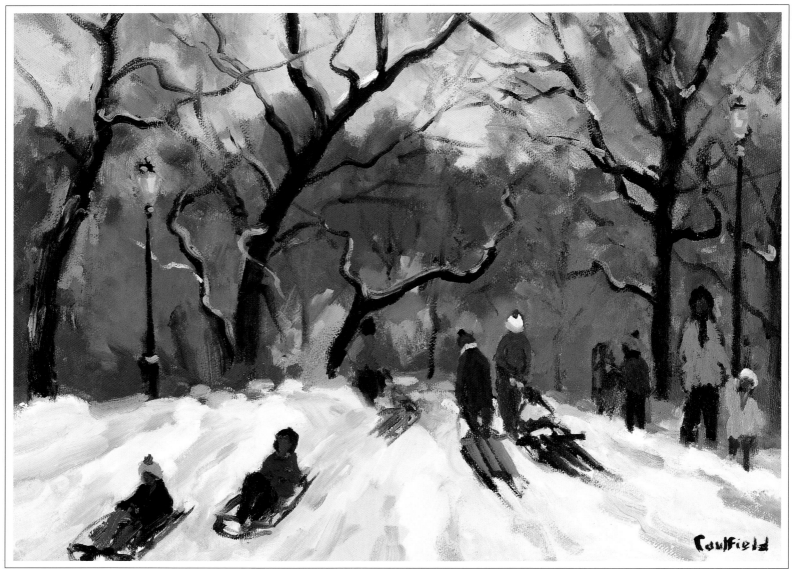

Sledding In Central Park, NYC 12" x 16" oil on canvas

Collection of Jay and Marni Grossman

In 1998 I was exhibiting at ArtExpo in Manhattan, when the city was hit by a ten inch snowstorm. I headed off into the park to do some sketching. As the snow fell, a school bus pulled up behind the Metropolitan Museum of Art and dropped off about twenty children. What caught my eye was the tree at left center, with its twisting, snow-laden branches. This tree contrasts nicely with the motion of the children playing and sledding.

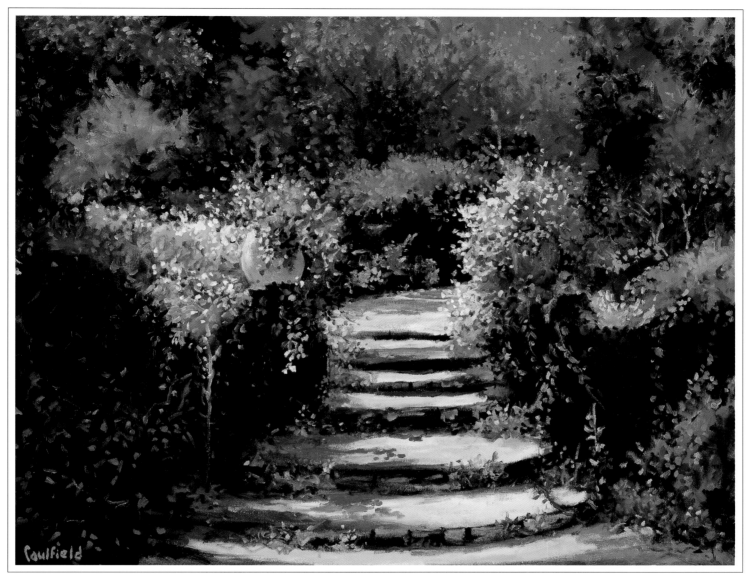

Garden Steps, Cancale 24" x 30" oil on canvas

Collection of Keith and Nancy Getter

These flower-strewn steps lead to a fantastic garden behind what is now a hotel. Once a private French home, it was commandeered by the Nazis in World War II. I can still recall walking down these steps with Marilyn, turning around, and being struck by the overwhelming natural beauty of this spot. My youngest son thinks this is the best painting I've ever done.

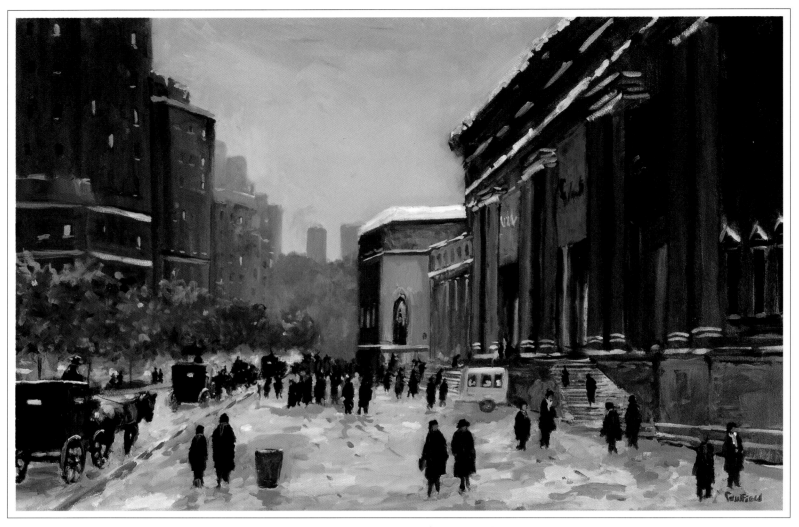

Metropolitan Museum, NYC, Winter 20" x 30" oil on canvas

Collection of the artist

I did a smaller version of this painting years ago. A winter snowstorm can often present a softer and less hard-edged New York. A few years back my wife, Marilyn, and I had driven to the city from Vermont at 3:00 AM, through a blinding blizzard, in search of fresh subject matter. Following a walk through a winter wonderland Central Park, we came upon the Metropolitan Museum, and I immediately began sketching. The solid mass of the building contrasts nicely with the activity of the pedestrians going about their day.

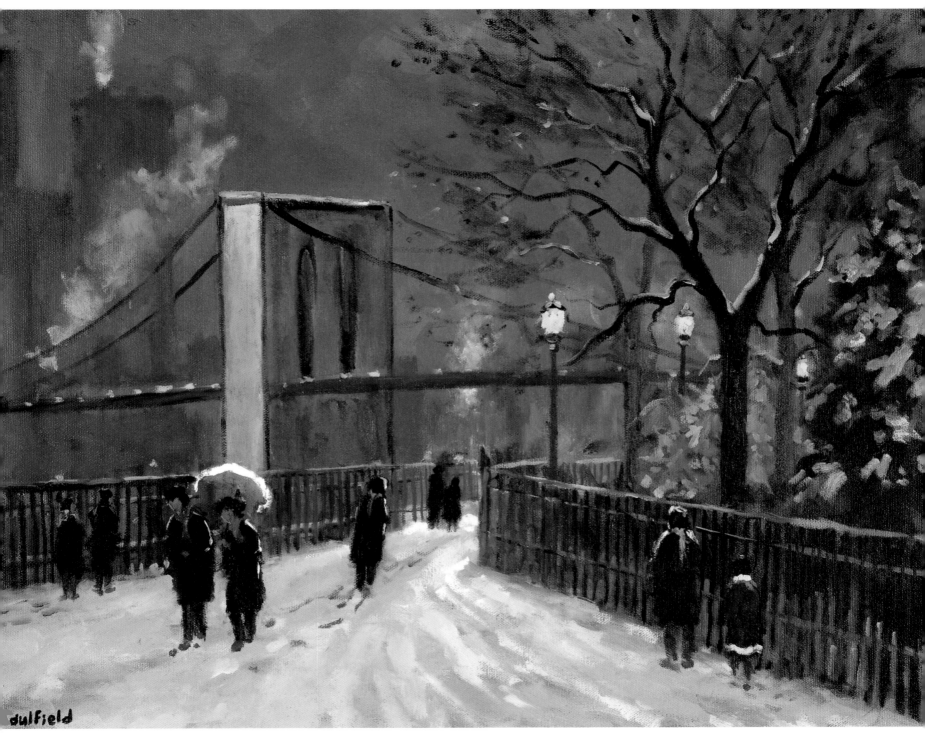

Brooklyn Promenade 16" x 20" oil on canvas

Collection of the artist

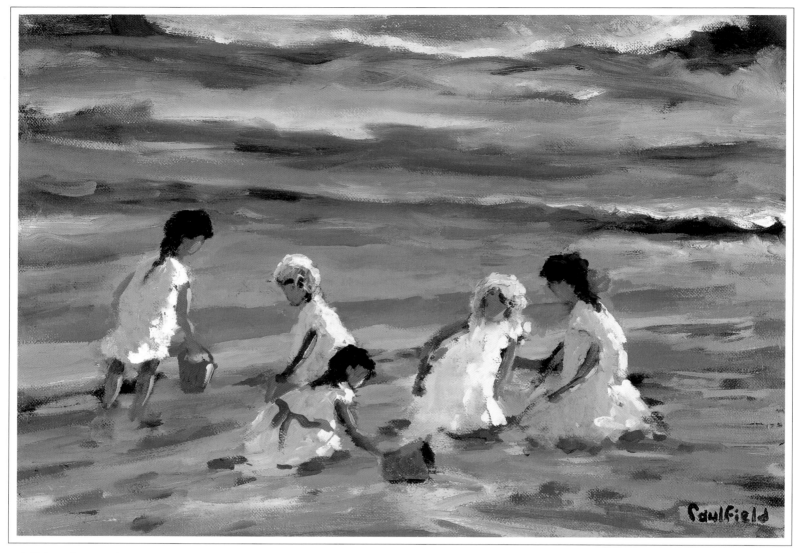

Children's Beach Day 10" x 14" oil on canvas

Collection of the artist

Having spent my adolescent years in the coastal city of Lynn, Massachusetts, I've always loved the beach. One of my favorite subjects is children playing along the shore. It brings back memories of sunny summer days filled with family and friends. The girl in white leads your eye into the painting. Tones of yellow ochre and Naples yellow, plus hints of blue and purple in the water, suggest a sunny summer afternoon.

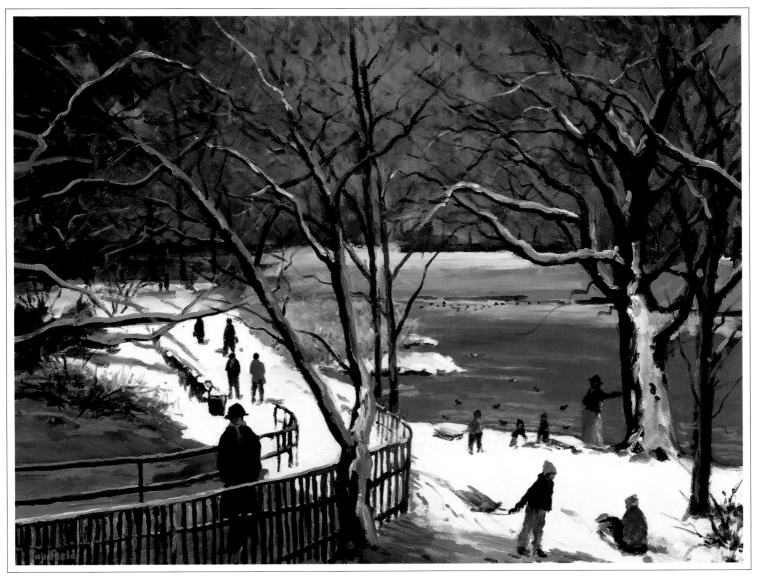

Sledding, Central Park 22" x 28" oil on canvas

Private Collection

Photographing a scene preserves the moment in light and shadow, so I always have my camera with me. The character of a dark and cloudy winter day here is obvious. Predominant colors are white and purple, with trees offset with burnt sienna. Working from a series of photographs, I added children sledding and more snow than usual on the branches.

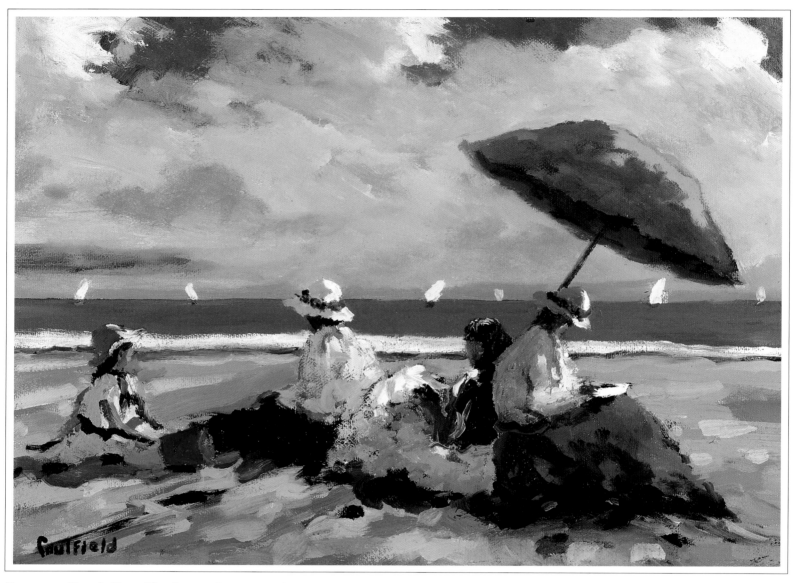

Summer Beach Day Shadows 9" x 12" oil on canvas

Collection of the Bone's

The loose brush technique I used in this painting allowed me to emphasize the values of light and shade, as well as the dynamics between the figures. This piece generates a certain energy and tension, carried through in the shadows on the sand, and relieved by the soft pastel sky.

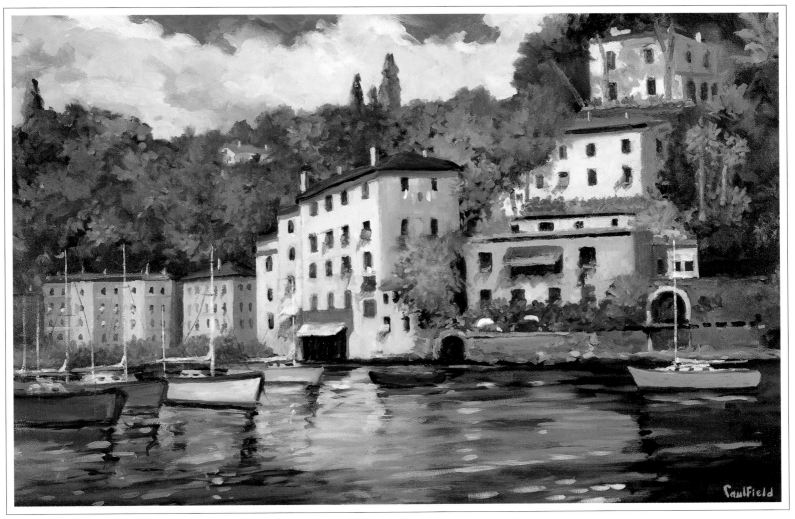

Entrance to Portofino Harbor, Italy 20" x 30" oil on canvas

Portofino is considered by many to be one of the most beautiful harbors in the world. My impressions were no different. When I first set eyes on the pastel buildings surrounding the water's edge, with mountains rising behind, I thought it was a painter's paradise. That first impression became this painting. As usual, I set about making a number of sketches and taking photographs, and in this case I did a small preliminary oil painting on the spot.

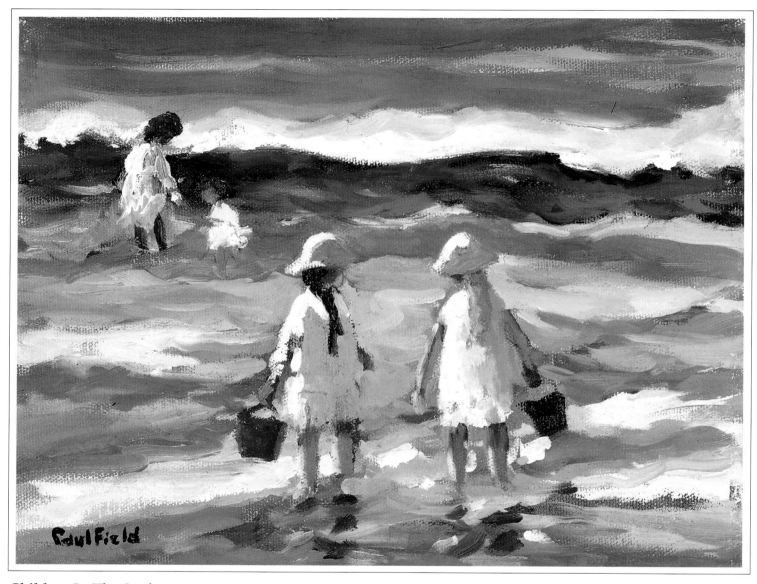

Children In The Surf 8" x 10" oil on canvas

My grandchildren love the beach every bit as much as I did at their age, and they inspired this scene. I handled this composition with an "S" factor, with the children breaking the plane in the foreground. The two background figures balance the scene and add depth. I minimized perspective to focus on the sensory aspects of surf and reflected sunshine.

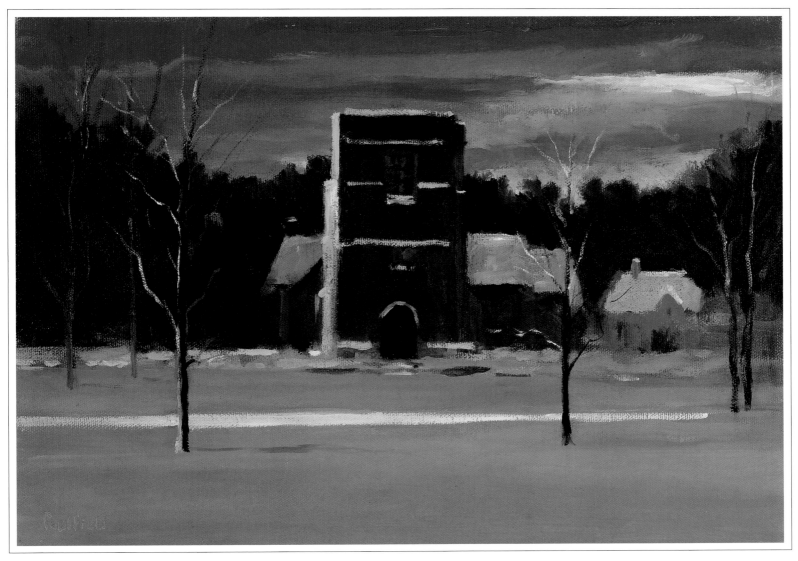

St. James Church, Woodstock 10" x 14" oil on canvas

I like the simple lines of this church on the Green
in the center of Woodstock. The winter sunsets in
Vermont are often quite subtle in their beauty, and
I tried to capture that effect here.

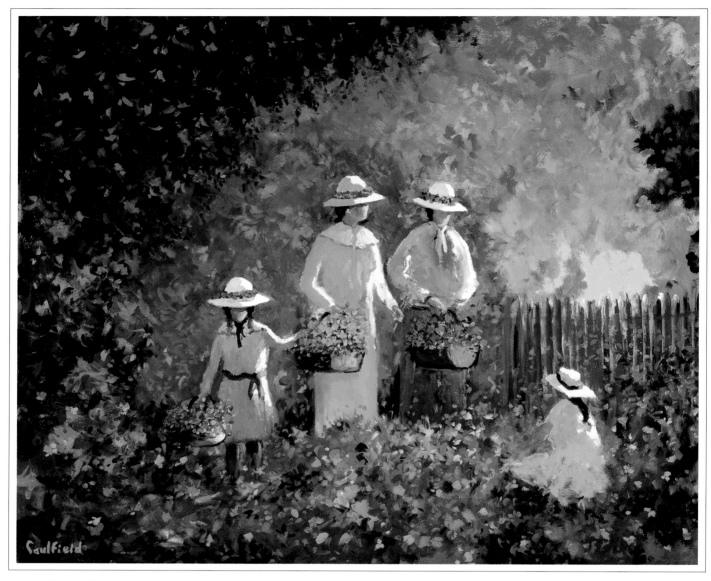

A Stroll In The Garden 30" x 36" oil on canvas

Collection of Kevin and Sheila Quinn

Here I wanted to guide the viewer's eye toward
the center of the painting, by using darker colors
on the edges and lighter colors bursting with light
in the middle. This technique was often practiced
by the Old Masters. The picket fence was added
to strengthen the overall composition.

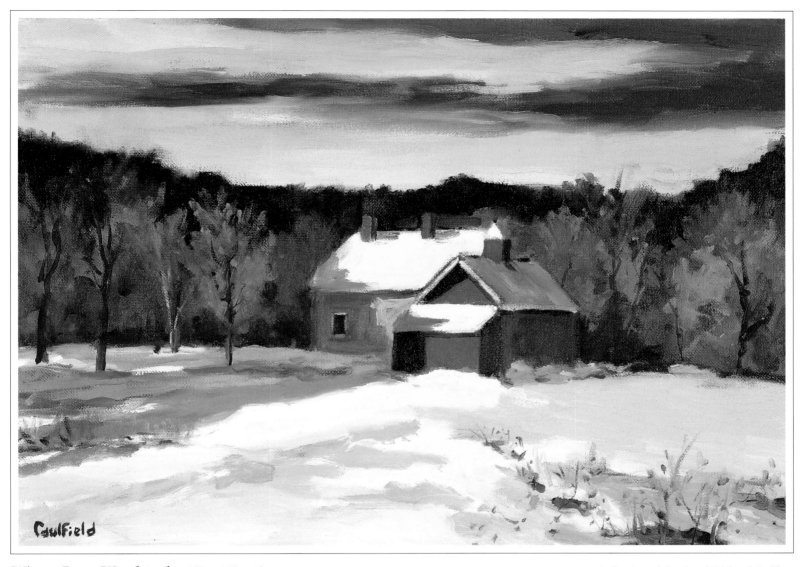

Winter Barn, Woodstock 10" x 14" oil on canvas

Collection of Carol and Richard Godfrey

The rich red color of the barn sets the tone for this painting by casting a strong shadow to the left. A calm winter sky casts interesting patterns of sunlight on the snow, framing the barn and house as the center of interest.

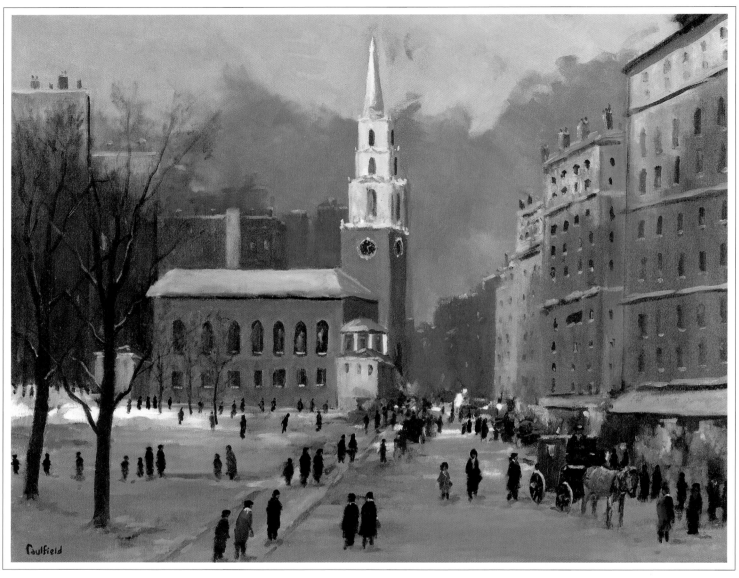

Park Street Church, Boston 24" x 30" oil on canvas

Collection of Jay and Marni Grossman

By the late 1990s I hadn't painted a Boston scene for
almost five years. On a visit to the city I passed the
Park Street Church; as the snow fell, I made a few
sketches. The foreboding sky and dark notes of the
surrounding buildings emphasize the church as the
center of interest. Foreground shadows are offset by
the reflected city lights and a streak of sunlight slic-
ing across the snow-covered Boston Common.

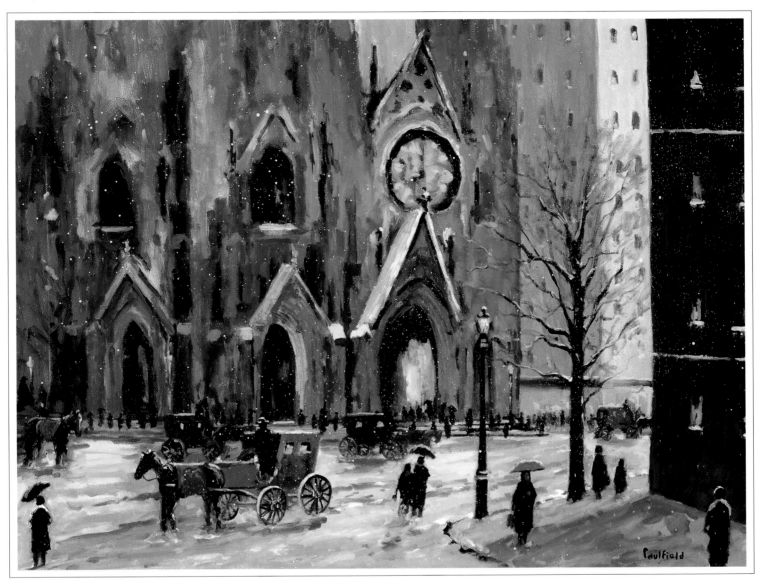

Saint Patrick's Cathedral, NYC 20" x 24" oil on canvas

A more fluid style is used here to convey the grandeur of this 5th Avenue landmark. I abandoned detail to let the purple shadings of the imposing dark edifice set the mood. The time of day is set in late afternoon, so the interior lights of the church would cast an iridescent glow.

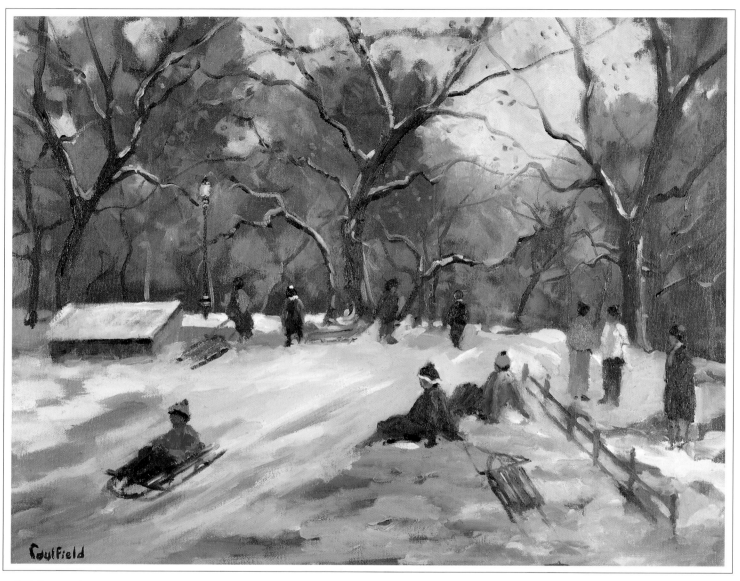

Children Sledding, Central Park 16" x 20" oil on canvas

Collection of Mr. and Mrs. James H. Fordyce

I used the same fluid brushstrokes in this painting as I did in *Sledding In Central Park, NYC (page 104)*, but the values here are somewhat darker. Children playing in the snow is one of my favorite subjects.

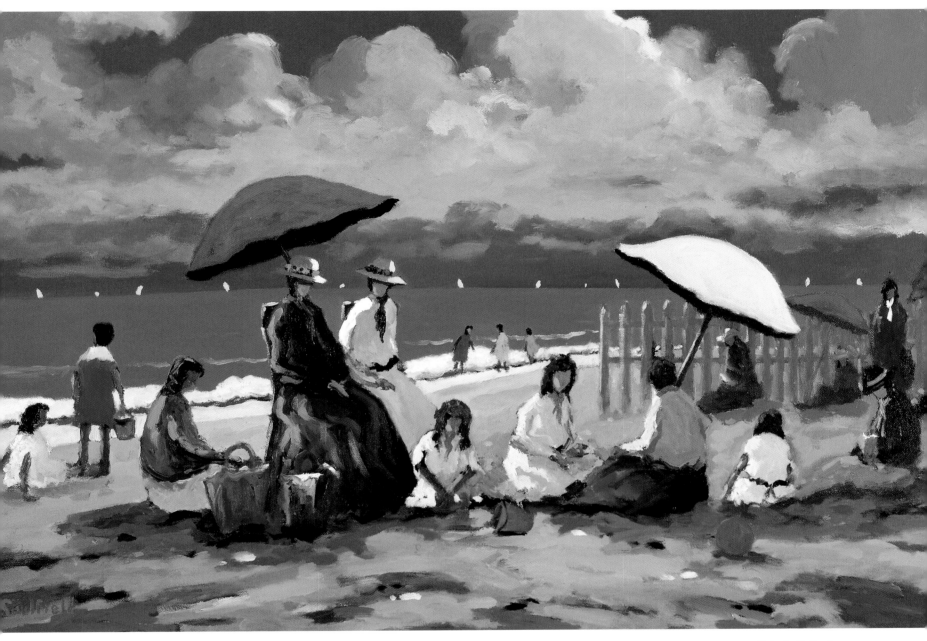

Beach Shadows 20" x 30" oil on canvas

Private Collection

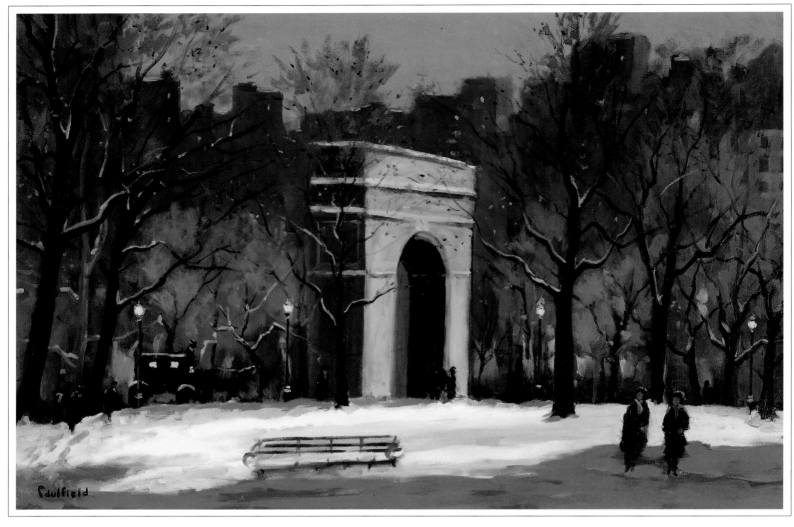

Washington Square, NYC, Winter 20" x 30" oil on canvas

Collection of the artist

Scores of artists have painted this monument through the years. One of my favorites was Everett Shinn. John Sloan, William Glackens, and a number of other painters affiliated with the "Ashcan School," lived and painted in surrounding Greenwich Village. Although numerous benches dot the park, I wanted to suggest a single bench front left in deep shadow. This, along with the two figures, adds a tone of mystery.

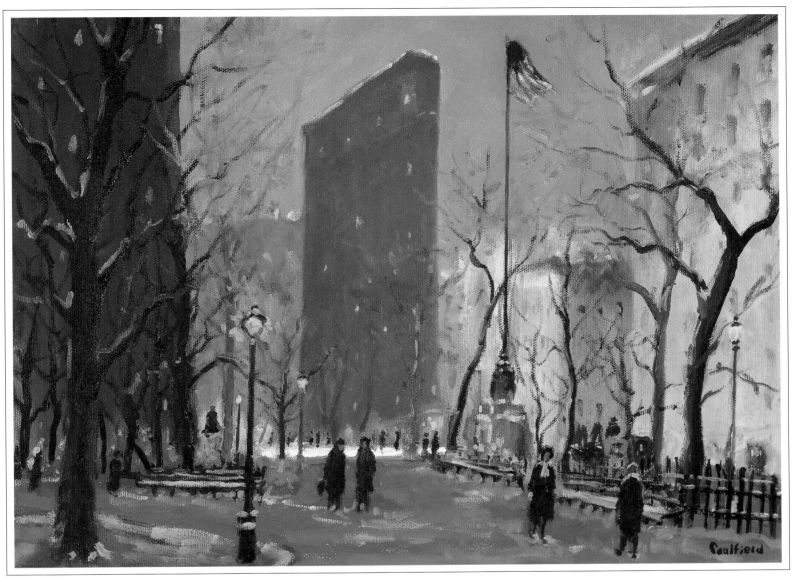

Flatiron Building, NYC 12" x 16" oil on canvas

The lofty buildings of New York City throw deep shadows as the day progresses. A walk through Madison Square one winter afternoon led me to this scene. The strong counterpoint of clear blue sky and approaching darkness in the foreground accentuate the flag, creating a second area of interest to that of the triangular Flatiron Building.

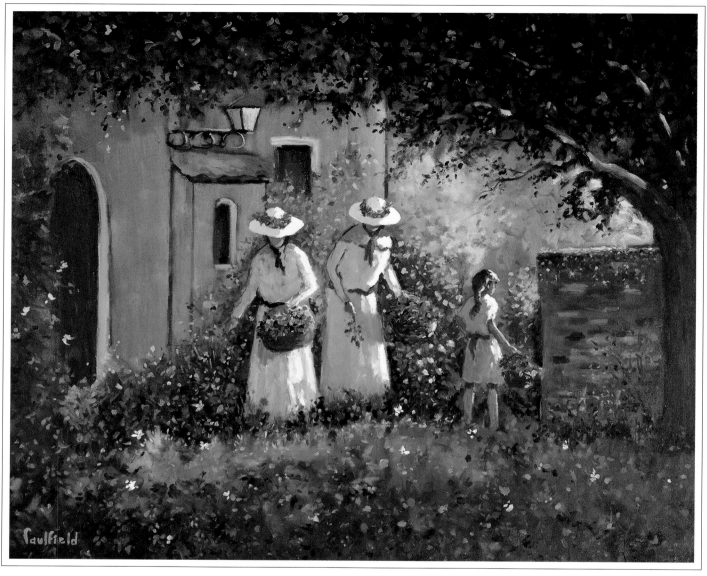

Quiet Moment In The Garden 30" x 36" oil on canvas

Collection of the artist

The charming village of Provence, France, is an eternally favorite destination of Marilyn's and mine. One trip can supply me with years of material. In this large painting a soft but dynamic back light illuminates the figures, while the tree branches and the abundant flowers create a bower of shadow and color.

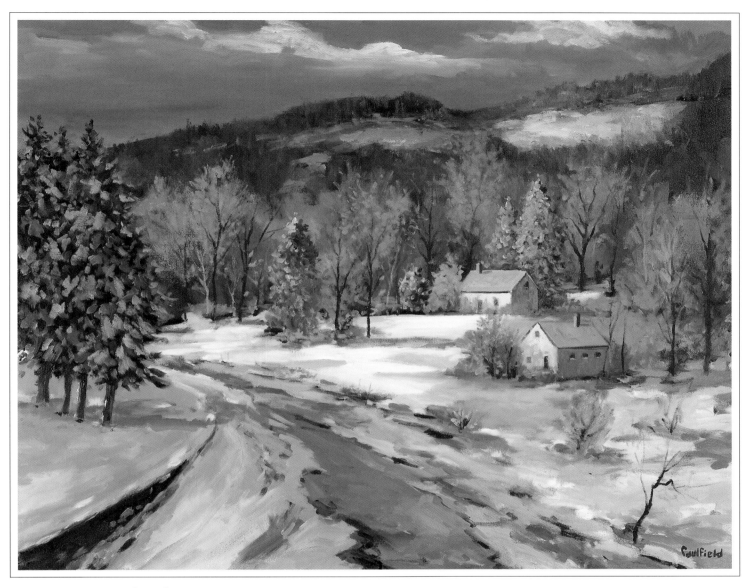

Mount Tom, Woodstock 24" x 30" oil on canvas

The village of Woodstock lies on a valley floor, surrounded by the glacier-rounded Green Mountains. The Ottaquechee River meanders through it. Mount Tom sits directly in Woodstock's center, and I walk by this particular scene every day on my morning walk. Highlighted with a bright sun at its peak, the mountain is covered with leafless winter trees and snow-covered evergreens.

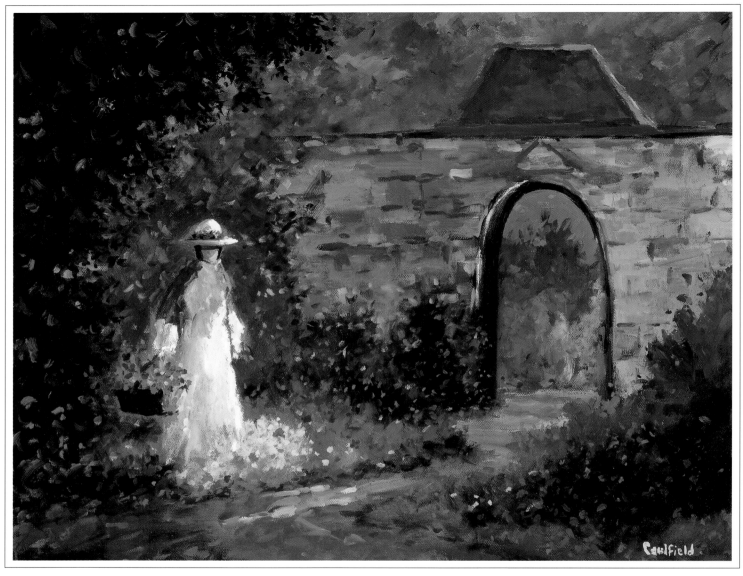

Morning Light, Provence 16" x 20" oil on canvas

Private Collection

After a trip to France, I visualized a woman bathed in light near an old stone gate. Looking back through my sketches, I found the gate I wanted, and the painting proceeded quite rapidly. Using very dark forms of green made the woman the focal point. The sharp perspective of the walkway moves the viewer's eye toward the stone gate.

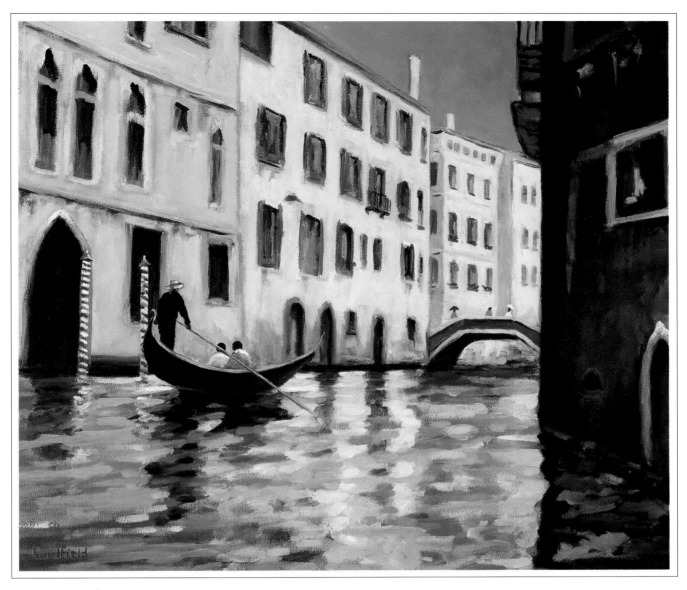

Venice Canal 20" x 24" oil on canvas

During the two-week stay in Venice, my wife and I went on many gondola rides. The pastel buildings bathed in bright sunlight are offset by the cool color on the right. The lone gondolier is the focal point of the painting.

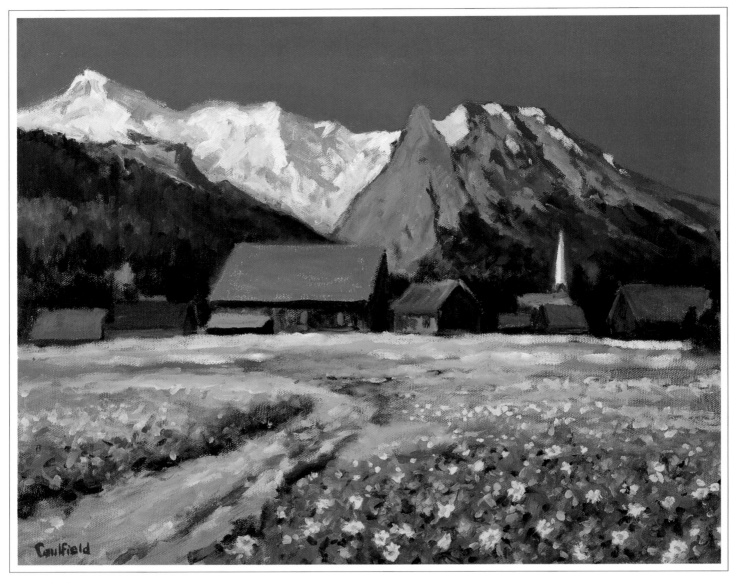

Garmisch, Germany 20" x 24" oil on canvas

Collection of the artist

Two years ago I went to Garmisch, Germany to do three paintings for a client. Scenes such as this are quite common where you would see flowers on the valley floor and the snow covered alps in the distance. In this painting the mountain peak is in a brilliant sun light while the foreground flowers are a subdued yellow, so you can focus on the small village and feel the majesty of the alps.

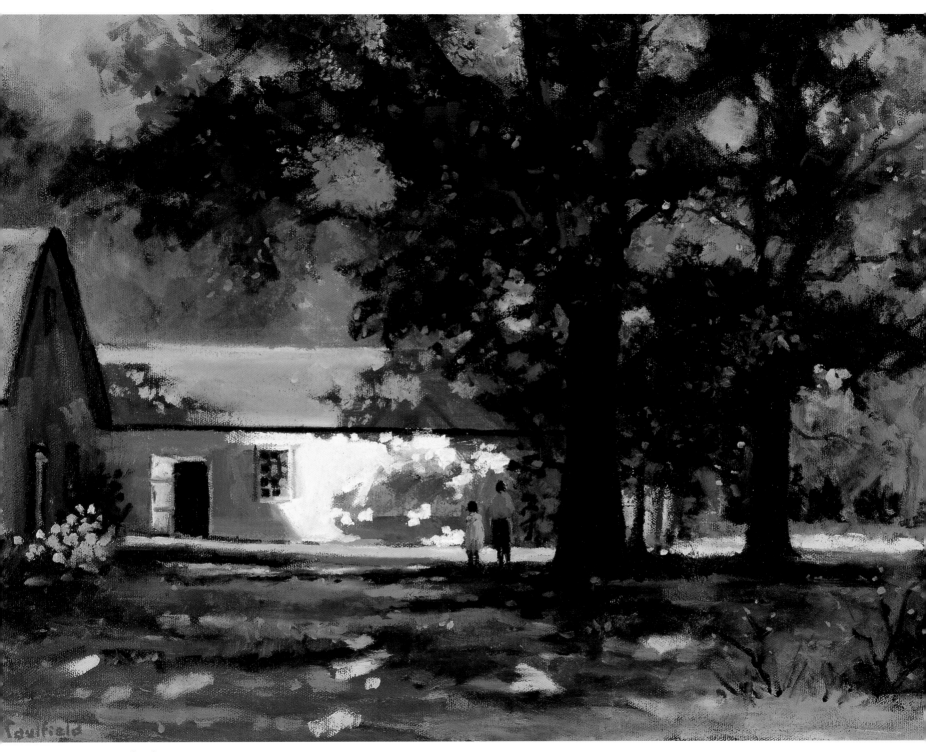

Autumn Shadows 16" x 20" oil on canvas

Collection of the artist

Index